Challenge Checklist continued on back inside cover

100 LIFE CHALLENGES

"The journey of a thousand miles begins with one step."

-Lao Tzu

Follow us on social media!

Tag us and use #piccadillyinc in your posts
for a chance to win monthly prizes!

Piccadilly (USA) Inc.
12702 Via Cortina, Suite 203
Del Mar, CA 92014
USA

10 9 8 7 6 5 4 3 2 1

Printed in China

ISBN-13: 978-1-62009-694-9

Table of Contents

Table of Contents

Continued

Introduction

Self-Care, it seems simple enough but chances are that if you're reading this, you're already thinking/wishing/hoping that the day had more time for YOU in it. The truth is that it can feel a lot easier to take care of others as well as other situations, projects, and tasks before we take care of ourselves. But I'm here to be brutally honest with you, the more you show up for yourself, the more you actually will help support, encourage, and serve others. Ready to see how that works? Keep on reading...

Throughout this book you'll find 100 Self-Care Challenge ideas complete with tips, ideas, and calendars to track your progress. Some will seem super easy while others will require a bit more time and effort. I'm a big believer that self-care doesn't have to be overly complicated and that the more we practice making time for ourselves, the easier it gets, the better we'll feel, and the more you'll make yourself a priority in your own life.

You may have heard the saying, *"what gets measured, gets improved"* and that's exactly what this journal is all about. Remember how good it felt to get a gold star as a kid? Checking off boxes as an adult now can feel just as rewarding. When we create an awareness of what we're accomplishing, big or small, it fuels and inspires us to take even bigger action. Taking the first step is what eventually gets us to run the first mile.

This book is about getting you to take small steps that will inspire and encourage you to see the value in investing in yourself in the long run. Some of these challenges may seem rather surface level and that's because they are. I wouldn't ask you to run a marathon without training, stretching, and setting your game plan first. I also won't set an expectation that you should drop everything and devote 110% of the rest of your days only to you, because I know from experience that it doesn't work that way. I know that there's a community aspect to how daily priorities work and how life ebbs and flows. I'm going to show you how to find a balance and new ways of living that truly allow you to make room for your own health and happiness.

Starting small creates a path and the energy you need to dive into even more powerful self-care unique to your needs, dreams, and goals, in the future.

When I work with clients the big changes they experience often feel like they happen suddenly. It's not until I remind them of all the micro steps they took that they see how they created their own momentum and truly made their big goals become a reality.

" To love oneself is the beginning of a lifelong romance."

-Oscar Wilde

How to use this Journal

Whether you start with the first challenge or randomly flip to one that calls to you, I invite you to use this journal in a way that feels good to you. If a challenge seems too simple or too elaborate, adjust it in a way that appeals to you. Extend past the 30 days if something feels amazing, tweak or alter things that don't feel aligned, and overall, use these as a springboard to explore various areas of self-care you may not have explored before.

Each challenge includes a 30 day calendar to track your progress. Mark your progress in creative ways that feel fun to you. Whether that's coloring them in, using stickers, highlighters, or simply checking them off as you go.

This book was written conversationally, in other words, I'm writing to YOU, not to any formatting standard and you may find that my grammar is far from perfect. I've spent years of my life writing papers in APA and while important, this journal isn't a research paper or professional document, it's a tool to help you create more self-care rituals in your life.

Make sure to share your progress and your journal pages with the hashtag
#100LifeChallenges

About the Author

Sarah Steckler is a Life Coach & Self-Care Strategist who helps women de-clutter their mind, simplify their life, and live with more aligned intention. She's the founder of The Brazen Heart Collective, a community focused on personal growth and clearing techniques, the creator of The Financial Self-Care Budget System, a Self-Love Guide, as well as her signature course, the Self-Care Alignment. Sarah helps women simplify their life with productivity, time management, intention setting, and daily routines that integrate the body and mind together as one functioning way of living. She believes that the more we take time to clear and simplify our lives, the more room we'll have to accept what we truly desire. Sarah is a Certified Health & Wellness Coach. She studied Health & Wellness Coaching and Integrative Health Practices at Maryland University of Integrative Health and received her Master's in 2016. She holds a B.A. in Communications with a minor in Sociology from Western Washington University. Sarah currently lives with her husband and bulldog in a 500 square foot tiny house.

Learn more about and find resources at **SarahRoseCoaching.com**

Challenge 1

*I*f there's ever a way to improve your happiness, motivation, and overall mental health, gratitude is one powerful tool to get you there. Research has shown that regularly practicing gratitude can help you focus on the positive and step away from getting stuck in negative thought patterns. Don't feel bad though if you find yourself in phases of feeling negative, our brains are actually wired to focus on what's not going well and it takes some practice to get ourselves to see the good in more and more situations. Think of practicing gratitude as building a new pathway in your brain. Like forming any new habit, after a while, new ways of thinking become automatic and we don't have to expel as much mental energy for them over time.

On the next page you'll find space to write down 3 things you're grateful for each day for the next 30 days.

A few tips to get you started:

Focus on the things that seem overly obvious (hint: these are things we tend to take for granted).

A few ideas might be:
- "I'm thankful for running water."
- "I'm thankful for my morning coffee."
- "I'm grateful that I have a roof over my head."

Consider things that went well when they could have gone worse:
- "I'm thankful I was only 10 minutes late to work and not 30."
- "I'm thankful that even though I missed the first half of the meeting, I gained valuable insights at the end."

Think about things that made you smile throughout the day:
- "I'm thankful that my coworkers remembered my birthday."
- "I'm grateful to the person in front of me that paid for my latte."
- "I'm thankful for how many times _____ made me laugh today."

"Acknowledging the good that you already have in your life is the foundation for all abundance."

-Eckhart Tolle

Calendar Tracker

Day 1	Day 2	Day 3	Day 4	Day 5
Day 6	Day 7	Day 8	Day 9	Day 10
Day 11	Day 12	Day 13	Day 14	Day 15
Day 16	Day 17	Day 18	Day 19	Day 20
Day 21	Day 22	Day 23	Day 24	Day 25
Day 26	Day 27	Day 28	Day 29	Day 30

Challenge 2

*I*f you're new to meditation, I have some good news for you, it doesn't mean you have to sit perfectly still with a perfectly clear mind. In fact, getting to that point takes practice and is a result/benefit of practicing meditation over time.

Meditation has found its way into mainstream media and is often misrepresented. Meditation in itself is the state of building an awareness with both the mind and deep consciousness, it is not a religion, and has many scientific benefits that can be and have been verified. Meditation is an act of being present in the moment we are in, it means developing a distinct focus and takes practice over time to experience the benefits. Meditation practices follow a variety of techniques, principles, and methods, and while some may argue there is only one true way to meditate, I personally have experienced various benefits from trusting in my intuition and the process of my own growth as I go along.

Some beginner tips for starting a daily or regular meditation practice.

Find somewhere comfortable

This doesn't mean you need to sit on a special blanket in the middle of the woods surrounded by crystals and incense (although tempting). What it does mean is that you want to be in a position that allows your body to fully relax. You may find that breathing in and exhaling as you build awareness around different areas of your body helps. I encourage you to worry less about the "perfect" meditation position and focus more on what feels comfortable for YOU. Again, give yourself permission to start from where you are.

Focus on your breath

Taking even 5 minutes to sit still and not scroll through our phones can sometimes be a hard first step. We're living in a time of go-go-go with constant distractions. Instead of worrying about how many thoughts come into your head (because you will have plenty of them at first), give yourself permission to start where you are and focus on your breathing. Each time you feel that urge to open your eyes, give up, or check your phone, come back to your breath.

Proper breathing

To get the most of your experience, make sure to breathe in deeply through your nose, hold, and then breathe back out through your mouth. After a few moments you'll notice a breathing rhythm that feels comfortable and soothing. To increase the power of your breathing, take time to do each step even slower.

Don't be afraid to use guided meditations

Help is your best friend. If sitting with silence is difficult for you at first, I encourage you to use a guided meditation that can help you focus on your breathing and the present moment. I have a free 5 minute guided meditation in my resource library on my website but YouTube can also be a great resource for meditations.

> ◗ *Use the calendar tracker on the next page to mark down each day you make time for meditation. Use smiley faces to indicate how it went each time.*

Calendar Tracker

Day 1	Day 2	Day 3	Day 4	Day 5
Day 6	Day 7	Day 8	Day 9	Day 10
Day 11	Day 12	Day 13	Day 14	Day 15
Day 16	Day 17	Day 18	Day 19	Day 20
Day 21	Day 22	Day 23	Day 24	Day 25
Day 26	Day 27	Day 28	Day 29	Day 30

One of the biggest ways we can incorporate more movement into our lives is to start somewhere small. I used to be a huge "all or nothing" person. I'd either be living it up on my couch eating sweets or trying to be "perfect" with my eating and injuring myself trying to run 10 miles a day on pavement—yikes!

The truth is, most people are really good at extremes. It can sometimes feel easier to go hard one direction or another. We choose a path and commit to it powerfully. Balance often feels like this elusive majestic creature we can't possibly work with but it can be a lot easier than we give ourselves credit for.

By committing to just ten jumping jacks a day, you're giving yourself a small goal that is easy to handle. It's a lot easier to start when things seem possible then it is to try to do something way outside of our comfort zone. Consider for a moment how much more likely you are to commit to doing ten jumping jacks a day than you would to a thousand. This is an example of a micro or tiny habit and while they can seem ridiculous at first, they are actually great ways to get yourself to start, which can sometimes feel like the hardest part.

Even if you're already in great shape or know the ins and outs of physical fitness, committing to a small goal like jumping jacks can help build your self-efficacy. With each day that we achieve our planned action, we feel inspired, capable, confident, and more encouraged to get out there and incorporate even more movement into our lives.

As you track your progress, consider getting a friend to join your or anyone in your house. It takes less than 60 seconds to do ten jumping jacks and together, you can all begin to work toward something much bigger. Feel free to add jumping jacks as you go and mark your progress. Notice how you start to feel physically and if your motivation changes. You may find that by day 7 for example, that you're more motivated to do 15-20-30 instead of ten. The entire point of these challenges are to build your awareness. Start from where you are and go from there!

"Exercise should be regarded as tribute to the heart. "

-Gene Tunney

Calendar Tracker

Day 1	Day 2	Day 3	Day 4	Day 5
Day 6	Day 7	Day 8	Day 9	Day 10
Day 11	Day 12	Day 13	Day 14	Day 15
Day 16	Day 17	Day 18	Day 19	Day 20
Day 21	Day 22	Day 23	Day 24	Day 25
Day 26	Day 27	Day 28	Day 29	Day 30

Morning routines can be rough, especially if we don't feel fully rested. Hitting snooze and not giving ourselves enough time to truly get ready are both things that can result in eating breakfast on the go...or not at all!

I'm still guilty of not always taking time to eat mindfully. We can't be perfect all the time. By taking 30 days to mindfully eat breakfast, some amazing things can happen. You may start to notice how the types of foods you're eating make you feel and how they impact your energy in the first few hours of the day. This can lead to healthier choices and longer lasting energy!

What exactly is mindful eating? Mindful eating is the practice of building your awareness around food, how your body reacts to different foods, as well as the different ways in which you find yourself responding to various flavors, textures, and temperatures. Eating can become much more rewarding when we take time to notice and learn our own hunger cues, how various foods affect our energy levels, and how certain foods tend to keep us feeling fuller longer.

Totally new to this whole mindful eating thing?
Try this basic practice to get a feel for what it's all about:

- Start by choosing a small cracker or piece of fruit
- Take a few moments to look at the food, consider its shape, size, smell, texture
- Take a small bite and let it roll around on your tongue
- How does it taste? How does that first bite feel?
- How would you describe the flavor, the texture, the way it makes you feel?

Starting with these basic questions and observations can help you become more aware of the speed at which you eat and how that affects your perception of your hunger, state of fullness, and even how aware you are of the flavor of what you are eating. Ever notice that after a few handfuls of chips they don't taste like much anymore? Coming back to a place of mindful eating can help you really savor the experience and may help prevent you from overeating as well.

For this challenge, give yourself at least 10-15 minutes to sit down each morning and eat. Avoid looking at your phone or watching TV. Focusing on your eating will allow you to notice when you're truly full and satisfied. How often have you ate food on the go and not really tasted it? Sitting at the table can help you enjoy your food, after all, it's part of what makes life so wonderful.

Calendar Tracker

Day 1	Day 2	Day 3	Day 4	Day 5
Day 6	Day 7	Day 8	Day 9	Day 10
Day 11	Day 12	Day 13	Day 14	Day 15
Day 16	Day 17	Day 18	Day 19	Day 20
Day 21	Day 22	Day 23	Day 24	Day 25
Day 26	Day 27	Day 28	Day 29	Day 30

I hear it all the time, *"I wish I had more time to read!"* or *"I just don't have time to read books these days."*

You're not alone and there's a pretty big reason why more of us don't make time for reading. Being tired at the end of the day and mentally depleted can make anyone want to turn off their brain. And let's get real, zoning out on the couch, watching TV, playing video games, and scrolling through our phones can be a nice way to unwind. But if you're yearning for that aspect of mindfulness, learning, and self-growth, reading is one of the most cherished ways to step into that space.

I often marvel at people who read dozens of books each year and think *"wow, they must have so much time,"* when really, they are simply using their time differently. Adjusting their priorities, and creating awareness around their time and intention management.

I work with clients all the time who say that they have no idea where their time goes in the evenings. They get home from work or take a moment to breathe from taking care of the house or the kids, and then suddenly, it's bedtime. We use up a lot of our mental energy and brainpower throughout the day making decisions, focusing on projects, considering life questions, and trying to remember everything we need to accomplish. Many of us, myself included, are guilty of "shutting off" when we get home and not being present in an attempt to truly relax and unwind after a long day. There's nothing wrong with that and sometimes it's very needed but I can tell you that making time for more reading in my own life has increased my joy factor immensely.

By setting aside 15 minutes each night before bed, you're creating time and space to do something for you and your mind. Visit the library and choose a book, ask to borrow something from a friend, or pick up one you haven't touched in years on that shelf. Reading a real hard copy book allows your eyes to rest from all the blue light and helps your melatonin kick in so your body can ease into sleep mode. It's all about keeping that circadian rhythm in check.

As you read, notice how quickly you begin to make your way through a book. You may even find that using a site like GoodReads.com will inspire you even more to keep going!

"A book is a dream that you hold in your hand."

-Neil Gaiman

Calendar Tracker

Day 1	Day 2	Day 3	Day 4	Day 5
Day 6	Day 7	Day 8	Day 9	Day 10
Day 11	Day 12	Day 13	Day 14	Day 15
Day 16	Day 17	Day 18	Day 19	Day 20
Day 21	Day 22	Day 23	Day 24	Day 25
Day 26	Day 27	Day 28	Day 29	Day 30

Part of taking care of ourselves stems from creating rituals and routines that make us feel cozy, at peace, and bring in those feelings of home, nourishment, and safety. These are good vibes to feel where you live and sometimes as life gets chaotic, we can forget to come back to the basics. Consider for a moment how comforted you feel when you enter someone's home or even a restaurant where the lighting is warm; there's glowing candles surrounding the table, and there's a lingering scent of vanilla that makes you take in an extra deep breath. Ahhhh, that stuff is the best. Why not create that experience in your own home?

Within the first 10 minutes of getting home, make it a priority to light a candle, burn some incense, or turn on an oil warmer or diffuser. Not only will it serve as a reminder that you are welcoming yourself home, but the scent will give you a powerful reminder to ease into the evening. Tying a scent to a moment or experience is also a strong way to build an elicit memory, or a memory that stays with us long-term. Olfactory memory is one of the strongest triggers for remembering specific events and experiences. I still think of my Mom tucking me into bed at night when I smell rose perfume. Something she used to spray to keep werewolves away when I was little and scared of monsters breaking into my room. Moms are so smart.

Consider some of the scents and smells that bring you back to pleasant memories. Incorporating warm scents and routines in your life can help you build on that same experience.

A few ideas for scents to use and their meanings:

- Try a lavender candle or essential oil to calm your mind and body
- Use peppermint, lemon, or cinnamon to help bring you out of fatigue
- Try rose or chamomile to ease an irritable mood

Look into aromatherapy and essential oils to learn more about how various scents can connect you and bring health to the mind, body, and spirit.

"Silence is a fence around wisdom."

-German proverb

Calendar Tracker

Day 1	Day 2	Day 3	Day 4	Day 5
Day 6	Day 7	Day 8	Day 9	Day 10
Day 11	Day 12	Day 13	Day 14	Day 15
Day 16	Day 17	Day 18	Day 19	Day 20
Day 21	Day 22	Day 23	Day 24	Day 25
Day 26	Day 27	Day 28	Day 29	Day 30

Challenge 7

I have a deep love of hand written letters. I go through stamps like crazy and am always excited when the Post Office releases new styles, designs, and types for various holidays. Writing a letter to someone is a wonderful way to show you care and let them know you were thinking of them.

It's also a gesture that many of us rarely experience anymore. Think about the last time you found a letter or card in the mail from a friend and how it felt. There's nothing quite like it, especially when it's a surprise.

You may be wondering how writing someone else letters is an act of self-care. When we take time to sit down and handwrite something, we are creating a mindful moment. You can increase the experience by clearing a space on your desk, lighting a candle or turning on a Himalayan salt rock lamp, making a cup of tea, and focusing in on what you'd like to share. Not only are you reaching out to someone you care about but you're also checking in with yourself, considering things like:

- What do I want to let them know about my life?
- What moments have recently brought me joy?
- What's something funny they need to hear about?
- What's something they might not be aware of that could deepen our bond/connection/friendship?

This may seem like a daunting task, especially for 30 days, but if you take a few minutes to outline your goals in advance, you'll find that you can write a letter or a card in less than 10 minutes each day.

- Start by making a list of everyone you'd like to write a letter to
- Decide how many letters you might send to each of them
- Round up any envelopes, cards, or stationery you have

Ideas for letters & cards:
- Write a memory you loved sharing together
- Leave a quote that you know will resonate with them
- Add some glitter or confetti to the inside of the card
- Draw a doodle or get creative with stickers
- Write a short list of things you love about them
- Let them know something you appreciate about them
- Write down things you admire about them
- Note the ways they've helped you grow

> ❍ *Make sure you write down the person you mailed a letter to and the date it was sent. Imagine how many smiles you'll create over 30 days!*

Calendar Tracker

Day 1	Day 2	Day 3	Day 4	Day 5
Day 6	Day 7	Day 8	Day 9	Day 10
Day 11	Day 12	Day 13	Day 14	Day 15
Day 16	Day 17	Day 18	Day 19	Day 20
Day 21	Day 22	Day 23	Day 24	Day 25
Day 26	Day 27	Day 28	Day 29	Day 30

Challenge 8

Write Down One Thing Each Day You Love About Yourself

*A*wareness is one of the best ways to increase joy in our lives. It gives us the ability to know what we want, when we need to take pause, and how to make room for more of the moments that light us up. It's easy to focus on things we don't like, especially when it comes to ourselves but by taking action each day to focus on the good, you can slowly change and shift the neuroplasticity of your brain and the habits of how your neurons fire. So cool, right?!

Getting in the habit of thinking about things we love about ourselves can be life-changing. And it can get us out of that routine of picking ourselves apart.

To get you started, I made a little list of things I love about myself that might inspire you:
- I love that I say what's on my mind and feel confident in using my voice
- I love that I cook and bake most things from scratch and am not afraid to experiment with recipes
- I love that I give myself permission to watch crappy reality TV shows (some of them are so addicting!)
- I love that I swear and don't feel guilty about it (sometimes it feels so good)
- I love that I make time for myself to move my body
- I love my creative mind and the abundance of ideas it comes up with each day

Things to consider:
- List out things you love that make you different
- Ask yourself what part of your personality brings you joy
- Think about the things you make time for that make you feel good
- Reframe things that bother you about yourself into things that can be seen as positive

By the end of 30 days, you'll have a pretty long list of things to come back to (and add to over time). This can be a great reminder to revisit when you're having a low day or need a little boost. Don't be surprised if it gets easier each day to think of positive qualities about yourself. Every time we practice something consistently, we improve. You may find that you end up writing down more than one thing each day, let it roll!

"Until you value yourself, you won't value your time. Until you value your time, you will not do anything with it."

-M. Scott Peck

Calendar Tracker

Day 1	Day 2	Day 3	Day 4	Day 5
Day 6	Day 7	Day 8	Day 9	Day 10
Day 11	Day 12	Day 13	Day 14	Day 15
Day 16	Day 17	Day 18	Day 19	Day 20
Day 21	Day 22	Day 23	Day 24	Day 25
Day 26	Day 27	Day 28	Day 29	Day 30

*W*atch TV for 30 days?! I know it might sound a little counter-intuitive but I'm telling you, when you schedule out and make time for things you like doing, you enjoy them more! A few challenges back, I talked about how it's common for us to come home and zone out in front of the TV. There's a big difference between doing something with intention and awareness vs. doing something mindlessly. A lot of us do things without giving ourselves that full permission. In other words, we don't enjoy watching TV because there's that voice in the back of our heads making us feel guilty, lazy, or unproductive.

It's all those times we watch TV or binge on a Netflix series only to feel guilty the entire time because there's all these other things we "should" be doing. Or we end up putting off things we need to take care of because we never make time to relax or enjoy things we love.

There is nothing wrong with watching a show you like. I don't care who might be telling you there are a bunch of other things that are way more important. It's hard to show up in your own life and be there for the friends and circumstances that need your full attention when you constantly feel drained and deprived.

For the next 30 days, I'm challenging you to set aside 30 minutes each day to catch up on those shows (or movies) you love and have been dying to finish. Maybe there's a new series you've wanted to try or a show you want to completely re-watch. Speaking from experience here, I've re-watched The Office four times now (it only gets better every time).

A few things that will help you set your intentions for this challenge:

- Consider giving yourself a minimum and maximum TV time. This lets you know the boundaries of what will feel good to you and so you don't end up feeling guilty for watching three hours of *Kitchen Nightmares*.
- Set a timer for your TV time and make sure it doesn't interfere with your bedtime. This whole thing won't feel so good if it starts interfering with your sleep.
- Decide what time you will watch shows at night. Will it be after dinner? Right when you get home? How can you make the most of this time for yourself?

Go grab some snacks, some cozies, and your favorite beverage and get to it!

" Life must be lived forwards,
but can only be understood backwards. "

-Kierkegaard

)))●● Calendar Tracker ●●(((

Day 1	Day 2	Day 3	Day 4	Day 5
Day 6	Day 7	Day 8	Day 9	Day 10
Day 11	Day 12	Day 13	Day 14	Day 15
Day 16	Day 17	Day 18	Day 19	Day 20
Day 21	Day 22	Day 23	Day 24	Day 25
Day 26	Day 27	Day 28	Day 29	Day 30

*E*ver notice that when you take care of things first thing in the morning or right when you get to the office, that the ENTIRE day just feels better? Oh yeah! It's because when we accomplish something, big or small, it's like having a tiny voice in your head saying, "Yay! We did the thing!" Making your bed helps you establish a morning routine and also helps you feel welcomed when you come back home (a lot like what we talked about in challenge #6).

Doing something routinely and consistently also gives you mental freedom in other ways. It takes away the element of choice first thing in the morning. Instead of getting up, stumbling around, and wondering what you "should" do, you already have a few answers and tasks to get you started.

It's a lot like having a template for a routine task within a project management system. Every time you have to complete that task, there's a process to follow, which eliminates using that extra brainpower to ask yourself if you're missing anything. Making the bed first thing can also help you set the tone for the day. The bed is made, things are orderly, you feel at ease.

Consider also how it affects the energy of your home and your mood. How does it feel when you come home to a bed that's made? How does it impact how invited you feel to go to sleep or relax at home? It may also bring your awareness to other things like, "Wow, I really never use those three extra pillows." Starting simple routine morning tasks helps you simplify your life and creates order to your day which impacts your overall mood, stress levels, and feelings of nourishment.

Fluff those pillows. Fold any extra blankets on top. Spritz some essential oil spray on that bad boy. Treat yourself to some luxury!

> ◑ Bonus tip: *Write down a word for how you feel each day when your bed is made. Notice how your mood shifts over the 30 days.*

" *In teaching others, we teach ourselves.* "

-Anon

Calendar Tracker

Day 1	Day 2	Day 3	Day 4	Day 5
Day 6	Day 7	Day 8	Day 9	Day 10
Day 11	Day 12	Day 13	Day 14	Day 15
Day 16	Day 17	Day 18	Day 19	Day 20
Day 21	Day 22	Day 23	Day 24	Day 25
Day 26	Day 27	Day 28	Day 29	Day 30

I never knew I loved cooking until I met my husband. I'm not sure what about him brought out the domestic side in me, but the moment I met him, part of me started chanting, "I WANT TO BAKE THIS MAN SOME MUFFINS!" And then after that calmed down a little bit (the "poor" guy had to eat so many cookies) I started finding so much joy in cooking and baking for myself.

Now, I'm not saying you're going to suddenly love cooking if you don't already. But you may just find that cooking one meal for yourself each day for 30 days brings a new form of mindfulness and awareness to your life.

Whether you throw together a salad with chopped veggies and dressing, whip up some spaghetti, or decide to go all in and make a giant meal from scratch, there can be real joy in being in the moment with food.

Some of my happiest moments are when I'm alone in the kitchen, chopping up potatoes, and reveling in the simplicity of that moment. Call me crazy, but being in the zone like that can be so rewarding and gives us a chance to let all that other chaos go, even if only for a moment. It has allowed me to fully step into an awareness of the kinds of foods I'm eating, where I buy them from, what they truly taste like, and the endless ways to prepare them.

A few tips:

- No need to make this hard on yourself, dive into simple recipes, ask friends for tips, check out websites with 5 ingredients or less.
- Let the perfectionism go. Some meals might not be perfect. Others may come out WAY different than you imagined. Enjoy the process, learn from the experience.
- Ain't no shame in the food delivery game. If trying out a meal planning service with all the ingredients and directions helps you commit, then go right ahead!
- Give meal prep a try! If you have more fun having a "meal prep party" on Sundays and cooking everything ahead of time for the week—that still counts.

Use the next 30 days of this challenge to test the waters with your cooking skills, techniques, and ingredients. Don't be afraid to try new things or step outside of your comfort zone!

Calendar Tracker

Day 1	Day 2	Day 3	Day 4	Day 5
Day 6	Day 7	Day 8	Day 9	Day 10
Day 11	Day 12	Day 13	Day 14	Day 15
Day 16	Day 17	Day 18	Day 19	Day 20
Day 21	Day 22	Day 23	Day 24	Day 25
Day 26	Day 27	Day 28	Day 29	Day 30

Challenge 12

Take a Walk Rain or Shine

Walking is one of the most underrated forms of exercise and movement. There have been times in my life when I didn't go on a walk because I didn't consider it a "good enough" exercise. But I want to challenge you to re-think daily walks for a moment. Instead of viewing them merely as a form of exercise for your body, consider how mentally clarifying a daily walk can be, especially outdoors.

Walking each day can be a wonderful way to ease your mind, reduce stress, take time for yourself, listen to a podcast, book, or your favorite music, or check out a new spot outdoors. Walking regularly has also been shown to improve cognitive function over time—keep that brain of yours full of smarts! Think about how often a good walk can provide clarity, focus, and intention to your day ahead.

The Japanese practice of Shinrin-yoku or the term "forest bathing" was coined in the 1980s as a way to take in the atmosphere of the forest and aid in health and wellness. It's been shown to help alleviate stress, reduce blood pressure, elevate mood, improve sleep quality, and increase the sense of joy within your life.*

But you don't have to walk through the forest in order to benefit from a daily walk. We've all heard that getting 10,000 steps a day can greatly impact our health. Walking for even 10-20 minutes a day can also give your mind a way to unwind and release any cycling thoughts. Sometimes the act of movement can allow us to gain deep clarity on something that's bothering us or an idea that needs an extra "oompf" of power.

Set a time that you'll walk each day and stick to it. Make sure you have the proper gear ready so various weather won't hinder your commitment. And if it helps, ask family members or people in the household to help hold you accountable...or join you!

A few things to help deepen your enjoyment and commitment along the way:

- Add something enjoyable to your daily walk; listen to a podcast, audiobook, or a playlist that brings you back
- Make sure you have comfortable shoes with the right support
- Download apps to track your progress like RunKeeper or invest in a step counter

Checkout www.shinrin-yoku.org for more information and research.

Calendar Tracker

Day 1	Day 2	Day 3	Day 4	Day 5
Day 6	Day 7	Day 8	Day 9	Day 10
Day 11	Day 12	Day 13	Day 14	Day 15
Day 16	Day 17	Day 18	Day 19	Day 20
Day 21	Day 22	Day 23	Day 24	Day 25
Day 26	Day 27	Day 28	Day 29	Day 30

Challenge 13

*J*ust like we discussed in challenge #10, having a clear morning routine can help make your day way more productive and less stressful. Whether you already have a solid morning schedule or not, waking up just 20 minutes earlier can give you extra time to start your day feeling calm, at ease, and ready to handle whatever may come your way. Just think what you could accomplish or have time for with 20 extra minutes each morning! One thing about most people is that we overestimate what we can do in a year and underestimate what we can do in shorter amounts of time.

I spent YEARS of my life rushing out the door, forgetting my lunch, feeling irritable, or plain anxious because I was worried I'd be late. No one was benefiting from me starting my day that way and my fridge was getting crowded with food I wasn't eating.

By getting up 20 minutes earlier, you can establish a game plan, or give yourself a moment to pause, collect your thoughts, or even better, sit down and slowly take in your morning coffee, tea, lemon water, or whatever it is you love to enjoy before the day starts stirring.

You may find that having that extra bit of time allows you to tidy up a bit, set the coffee for the next day, clean the counters, read a book, or reach out to a friend before you head out. Bonus tip here, use the extra 20 minutes to do something purely for yourself. It's a lot easier to rise and shine when you know the first thing you get to do involves something you'll enjoy. It will also be a lot more enjoyable if you stick to that solid bedtime routine so getting up earlier doesn't feel super difficult.

A few ideas for things you could do with those glorious extra 20 minutes:

- Set your intention for the day. Take a few moments to think about how you want to feel or what you'll look to find throughout the day.
- Practice affirmations or write your own*
- Do some yoga (pair this challenge with #50)
- Pull an oracle or tarot card for fun and new insights/perspectives
- Start journaling
- Write down 3-10 things you're grateful for (or more, no need to limit the good stuff!)
- Pack your lunch for the day
- Set yourself up with a tasty Crockpot® meal
- Read a book
- Visualize your goals/dreams

> ● *Get 44 days of affirmations to get you started at **SarahRoseCoaching.com/affirmations**

Calendar Tracker

Day 1	Day 2	Day 3	Day 4	Day 5
Day 6	Day 7	Day 8	Day 9	Day 10
Day 11	Day 12	Day 13	Day 14	Day 15
Day 16	Day 17	Day 18	Day 19	Day 20
Day 21	Day 22	Day 23	Day 24	Day 25
Day 26	Day 27	Day 28	Day 29	Day 30

Challenge 14

Spend 15 Minutes
Each Day Cleaning

*A*s I write this, I'm laughing because my bathroom is an absolute disaster. I'm the queen at letting the bathroom go until that moment when I say something like "HOW DID IT GET SO BAD IN HERE?!" and then try to blame the mess on everyone but myself.

It's one of the things I'm stubborn about and never want to do. What's crazy however, is that if I took just 15 minutes a day to tidy it up along with a few other things in the house, I wouldn't have to spend $4^1/_2$ hours in there and around the house once every few weeks doing a deep clean and hating life. I'm getting better at this, by the way, but man, I can't possibly be THIS messy.

It's like I have this illusion that if I clean my house once and really well, maybe it will just stay that way. But let's get real REAL for a moment, cleaning is a process and in some ways it's a lot like surfing, erm, I'm assuming. My point is, you have to ride the wave to avoid getting stuck underneath the water. Taking a little time each day to keep things tidy means that deep, arduous, annoying, frustrating cleaning doesn't have to happen that often, if at all.

One important note here. If you're in a family environment or living with roomies, cleaning is not your sole responsibility. In fact, if everyone in the house spends 15 minutes a day helping out, imagine how clean and tidy your place could be! I say this because one, *The Second Shift** is still prevalent in our society in various ways, and two, we could all use this reminder. *::Puts down sponge and walks away from the sink feeling empowered::*

Cleaning each day can serve as maintenance for your home and your sanity. I cannot tell you how many times I've been in a horrible mood only to realize the direct correlation to the number of dishes in the sink and my desire to want to punch someone in the face. A clean sink = safety and peace for everyone!

A few ideas for things to spend your 15 minutes on:

- Tidy up the sink of any dishes or clutter
- Wipe down countertops
- Do a quick clean of the toilet with the brush
- Vacuum a section of the house
- Wash the sheets or common area blankets
- Take out the trash/recycling
- Check the fridge for anything that needs to be eaten or thrown out
- Put away any clutter that ends up on that one chair or table

> ◖ **Book by Hochschild and Machung touching on the sociology behind women's work in the household*

Calendar Tracker

Day 1	Day 2	Day 3	Day 4	Day 5
Day 6	Day 7	Day 8	Day 9	Day 10
Day 11	Day 12	Day 13	Day 14	Day 15
Day 16	Day 17	Day 18	Day 19	Day 20
Day 21	Day 22	Day 23	Day 24	Day 25
Day 26	Day 27	Day 28	Day 29	Day 30

Challenge 15

Write a Letter to Your Future Self

*E*very time I work with a group of clients, I ask them to write a letter to their future self. I've been doing this for over a decade and I cannot tell you how fun and exciting it is when you get a letter from the past. Not only do I forget about it each and every time but I'm always amazed at how much things have changed, how many things have stayed the same, and how many details I completely forgot about. It's like asking yourself how much something you're mad about will really matter in a couple days, months, or years. Most of the time, it's a lot easier to let things go when you think about them this way.

I've written letters to myself a couple different ways. My favorite way is to use a site called FutureMe.org. It allows you to write yourself a letter at least 30 days into the future. Write your letter, click on the confirmation link email, and you're good to go. I've sent myself letters for months, years, and even decades later (that I've yet to receive). I've even had my husband write me a letter and I have no idea when he scheduled it for.

Another way is to write yourself a physical letter, seal it up and write the date you want yourself to open it. You can add these to a special box or even ask a friend to hold onto it for you and deliver it to you later. I'm sure there are services out there by now that do this as well.

A few ideas for things to write:

- Current weather, mood, thoughts
- Biggest challenges you're facing
- What you're most excited about
- The 5 people you are surrounding yourself with the most
- Your biggest wish
- What you're currently reading, watching, listening to, obsessed with...
- Something you want your future self to know
- A question for the future (it's so fun to be able to answer it later)
- Current events and popular songs
- Prices of gas, staple groceries, bills

Imagine getting 30 letters to your future self! Decide how far you want to schedule them out. 30 days, a year, every month for the next year. It would be really fun to stagger them out and receive one each month for 30 months. You decide!

)〗●● Calendar Tracker ●●〗(

Day 1	Day 2	Day 3	Day 4	Day 5
Day 6	Day 7	Day 8	Day 9	Day 10
Day 11	Day 12	Day 13	Day 14	Day 15
Day 16	Day 17	Day 18	Day 19	Day 20
Day 21	Day 22	Day 23	Day 24	Day 25
Day 26	Day 27	Day 28	Day 29	Day 30

*E*very now and then I remember how wonderful and relaxing it is to give myself a "spa day" at home. I often assume that in order to fully relax and pamper myself I'd need to spend lots of money, go to a special spa, or have an entire night to myself. Honestly though, even 10 minutes alone in the bathroom with a diffuser and some zen style music can bring me back to the present moment. Sometimes bathrooms serve as magical escape rooms, they truly are one of the only places where no one else will bother you, unless you have a cat or toddler who insists on being with you at all times. When I do take time to do something nice for myself, I also think, why am I not doing this more often? It comes back to that sense of perfectionism sometimes. Oh, well, I don't really want to do ABC unless I can also do XYZ...

The truth is, even taking 10 minutes to do a face mask for 30 days can feel so good. It's exciting and empowering to realize that self-care doesn't have to take hours out of our day. Even a simple 10 minutes can make us feel so much better. It comes back to the notion that small acts of kindness, especially toward ourselves, can have a big impact on our lives. Just like taking 10 steps a day would eventually lead you to a mile, taking a few minutes each day to pamper yourself will lead to an ever-increasing good mood.

For the next 30 days, make time to do something to pamper yourself. Whether it's a nightly face mask, doing your nails, trying out new makeup, trying out acupressure points, deep conditioning your hair, etc. Other ideas might include giving yourself a facial or hand massage (seriously there are YouTube videos out there that will show you how), dry brushing, or treating yourself to a special herbal tea.

You get to decide what pampering yourself means to you.

Bring on the feel goods!

"Who looks outside, dreams; who looks inside, awakes."

-Carl Gustav Jung

Calendar Tracker

Day 1	Day 2	Day 3	Day 4	Day 5
Day 6	Day 7	Day 8	Day 9	Day 10
Day 11	Day 12	Day 13	Day 14	Day 15
Day 16	Day 17	Day 18	Day 19	Day 20
Day 21	Day 22	Day 23	Day 24	Day 25
Day 26	Day 27	Day 28	Day 29	Day 30

Challenge 17

Watch an ASMR Video

*W*hat in the world is ASMR? Autonomous Sensory Meridian Response is the brain's reaction to specific stimuli that can send a tingly sensation throughout the body, down the neck or spine, or other areas of the body which leads to relaxation. In other words, it's a combination of sounds or soothing noises that trigger us into relaxed states. Like when someone whispers in your ear or when you hear someone in the distance humming a song.

Think about times in your life when someone whispered to you and you got a shiver down your spine or heard a noise that made you feel instantly relaxed. These moments can often feel unexplainable or random but are now actually scientifically validated as actual occurrences in our brain that trigger us into both calm mental and physical states.

ASMR is a relatively new found phenomenon that has gone viral on YouTube with millions of views. ASMR videos can be a great way to help you relax in the evening or calm anxiety and stress. I often listen to ASMR videos with my headphones before bed or after a long day.

What exactly are the videos? It depends on the artist you are listening to. Many are done as roleplays where you are the person being taken care of such as spa roleplays, office visits, doctor's exams, and so forth. While they may sound a little out there at first, I have been listening to these videos since early 2010 and they have greatly aided with insomnia and an active mind at night. Some videos are also just sounds such as tapping noises, crinkles, and other mouth sounds and clicks that people in the online community have mentioned seem to calm them down. There's no judgement in regards to the sounds or noises you prefer.

Listening to an ASMR video each day can be a great addition to a nightly routine or a way to calm down during the day. I will sometimes listen to them when I am doing other routine work.

Tips on getting the full experience:

- Listen to them with headphones
- Keep an open mind, it's about the sounds
- Find an ASMR artist that you like and feel like you relate to

> ◑ *Some of my favorite ASMR YouTube Channels:*
> - Gentle Whispering ASMR
> - Olivia Kissper ASMR
> - WhispersRed ASMR
> - Jellybean Green ASMR
> - Heather Feather ASMR

Calendar Tracker

Day 1	Day 2	Day 3	Day 4	Day 5
Day 6	Day 7	Day 8	Day 9	Day 10
Day 11	Day 12	Day 13	Day 14	Day 15
Day 16	Day 17	Day 18	Day 19	Day 20
Day 21	Day 22	Day 23	Day 24	Day 25
Day 26	Day 27	Day 28	Day 29	Day 30

*I*f there was one consistent way to elevate your mood, give you energy, regulate your body temperature, and help with digestion, would you stick to it? You've heard it a zillion times but when you're drinking enough water for your body, magical things start to happen. Not only does consistent water intake elevate your mood and give you energy throughout the day, but it also helps cushion your joints, supports your kidney functions, and allows you to digest foods efficiently. Basically, you become a walking, talking human unicorn...a hunicorn...this got weird.

How much water should you be drinking? Studies and doctor recommendations vary but if you aim for half your body weight in oz, you'll be feeling good in no time. Drinking enough water also supports your mental functions. Your brain is made up of about 75% water more water and dehydration can greatly impact short term memory function—say that again? It's why we can feel mentally foggy and have a hard time focusing when we've been chugging coffee all day and not enough water. It's another vital reason to get those fluids going before work, a big presentation or project, or when you know you'll need that extra focus and attention to be productive.

A few tips to make sure you get in the good stuff:

- Find a reusable water bottle you love drinking out of (I have a Raw Steel one that keeps the water cold and is BPA free)
- Track your water intake in your journal, on your phone, or on a notepad around your desk. If you're at home, keep a log on the fridge where you can mark off how many bottles you've drank
- Until you get in the habit, set a reminder on your phone or on the hour to take 5, stretch, move around, and gulp gulp gulp!

P.S. Yes, you will be visiting the restroom a little more frequently but over time your body will get used to your increased intake and things will settle down ;)

" It does not matter how slowly you go as long as you do not stop. "

-Confucius

Calendar Tracker

Day 1	Day 2	Day 3	Day 4	Day 5
Day 6	Day 7	Day 8	Day 9	Day 10
Day 11	Day 12	Day 13	Day 14	Day 15
Day 16	Day 17	Day 18	Day 19	Day 20
Day 21	Day 22	Day 23	Day 24	Day 25
Day 26	Day 27	Day 28	Day 29	Day 30

Challenge 19

I never forget the moments where a stranger did something incredibly nice and chances are, you haven't either. I grew up on Bainbridge Island just outside of Seattle so when I was attending college in Bellingham, I'd make quite a few trips on the ferry to visit family back home. One night on my way back after a holiday, I got to the booth and the attendant let me know that my car had already been paid for by the person in front of me. Immediately a rush of warmth surged through my body and a huge smile curled over my cheeks. I was so surprised by the gesture that I decided to pay for the car behind me. And on it went...

When we do something nice for others it can impact them in profound ways we might not be aware of. Another time during the holiday season in my early 20s, I was strapped for cash and trying to buy a few staples at the grocery store. The embarrassing moment occurred when my debit card was declined (due to a bill pulling early) and I didn't even have $12 to cover bread and some fruit. I stood there for a moment ready to try to fake a smile and apologize, when the woman behind me gave me a nudge and said in a quiet voice, *"Please let me cover this for you, it's the holidays, don't be so hard on yourself."*

Tears started to well up in my eyes and I couldn't believe how nice it was. I still felt incredibly guilty and embarrassed but in that moment, I decided that it would also make things a lot easier if I allowed her the opportunity she wanted to give by allowing myself to receive.

Part of the generosity of others requires allowing ourselves to receive, something that I still find difficult at times. But when you think about it, keeping that openness and loving kindness in our hearts is how we allow love to spread throughout our community.

For 30 days, I'm challenging you to commit to 30 random acts of kindness. This doesn't mean you have to pay for things for other people, although that could be part of it if you wish. Think small, start small, and see where that momentum takes you. There's also nothing wrong with this action making you feel good. It's our soul's way of saying we're doing the right thing ;)

◑ Some ideas to get you started:

- *Ask someone if you can help them.*
- *Write an email to a co-worker that has inspired you*
- *Bring in fruit, snacks, or something to share at the next group meeting you attend*
- *Take ownership of something someone else in your house usually does. Do the dishes without being asked, take out the trash, etc*

- *Send someone a small package of feel goods. Favorite snacks, a special card, stickers, tea, a list of reasons why they rock!*
- *Volunteer in your community*
- *Donate to an organization or charity you believe in*
- *Send a Facebook message to an old friend sharing a good memory*

Calendar Tracker

Day 1	Day 2	Day 3	Day 4	Day 5
Day 6	Day 7	Day 8	Day 9	Day 10
Day 11	Day 12	Day 13	Day 14	Day 15
Day 16	Day 17	Day 18	Day 19	Day 20
Day 21	Day 22	Day 23	Day 24	Day 25
Day 26	Day 27	Day 28	Day 29	Day 30

There was a time in my early 20s when I was living on my own and "doing my thing" and feeling really happy with how much freedom I had in my life. Yet after a while I realized that the whole "doing my thing" thing was resulting in me not taking very good care of myself. I had this pivotal moment where I couldn't remember the last time I had a banana.... or an apple, or any fruit for that matter and I got a little scared about how long I had been surviving off of boxed pasta and store brand crackers. The truth is that shifting your eating habits can start in subtle ways and lead to big results. I'm no nutritionist and I'm also not your bikini prep coach so I won't be giving you any hard and fast rules, but I will say that adding healthy foods to your day can feel a lot easier than only thinking about foods you're taking away.

Perfectionism can creep in when we want to eat healthier or make better choices about foods as well. It's that all-or-nothing mentality that can leave us feeling stuck, overwhelmed, and disenchanted in getting started. Instead of going *all-in*, consider starting with a simple daily habit.

The increased fiber from eating an apple or other piece of fruit each day can help with digestion. Also, eating fruit before a meal can help you feel more satisfied and be less likely to overeat. There are a plethora of additional health benefits to eating a serving of fruit each day, it all comes back to those small daily things you can do to keep up with the maintenance of your mind, body, soul, happiness, and well-being.

Eat a piece of fruit each day whether it's an apple, banana, orange, or serving of berries. Set a meal that you'll have it with or a time each day to have it as a snack. Notice how it feels to make even this small piece of fruit a priority in your day.

Consider how it smells, tastes, what the texture is like, and how it affects your energy level and your mood. You're diving into mindful eating already! Ask a coworker to take the challenge with you, or maybe your entire department. Have everyone bring in apples and leave a big bowl of them in the breakroom. See if your supervisor will help encourage people to have their fruit during meetings. Get your family, friends, or spouse to have a serving of fruit each day and create a reward or goal once you've all went through 30 days. Take on the world!

"I wouldn't sweat too much what it is, where it is or what you're doing, as long as you're learning."

-Melanie Whelan

Calendar Tracker

Day 1	Day 2	Day 3	Day 4	Day 5
Day 6	Day 7	Day 8	Day 9	Day 10
Day 11	Day 12	Day 13	Day 14	Day 15
Day 16	Day 17	Day 18	Day 19	Day 20
Day 21	Day 22	Day 23	Day 24	Day 25
Day 26	Day 27	Day 28	Day 29	Day 30

My grandmother was one of the most intelligent and detail oriented people I've yet to know. Even in her 80s she was doing daily brain puzzles and was more mentally alert than many of my friends in their 20s (just being honest). And while she had unfortunately smoked most of her life and was then on an oxygen machine to make sure she could breathe properly, she still had the mental energy of someone decades younger.

The reminders are everywhere to workout, get that exercise in, build those muscles, bro do you even lift?! But we forget that exercising our minds is just as important. Our body isn't a bunch of disconnected systems, it's a machine fueled and affected by every system in our body. When we workout more, we have more mental clarity, and when we have more mental clarity, we have more energy, and we can do more physical things with less stress.

After I completed my undergrad degree, I bought myself a Nintendo DSi as a graduation gift and man was I pumped! One of the first games I bought was Brain Age, which has puzzles and tests to assess your mental age. It wasn't fun as a new college grad to see a low brain age. I just spent four years getting my smarts, what gives!

What it did inspire me to do was challenge my brain more. Through puzzles, problems, different perspectives, and continued reading. Don't underestimate the power of crossword puzzles, they can seriously keep you making those sassy and witty remarks well into your 80s and 90s. Who doesn't love a sassy grandma? #LifeGoals

If you've never tried a Sudoku puzzle, do it. Contrary to what I thought for months, they have nothing to do with math and everything to do with patterns. Make 5-10 minutes over the next 30 days to do a puzzle a day. Even if you don't finish it in that time, you'll notice a difference in your mental clarity and strength.

You can find Sudoku puzzle books at the dollar store, most grocery stores, craft stores, and book stores. There are also phone apps to get you started.

"It always seems impossible until it's done."

-Nelson Mandela

Calendar Tracker

Day 1	Day 2	Day 3	Day 4	Day 5
Day 6	Day 7	Day 8	Day 9	Day 10
Day 11	Day 12	Day 13	Day 14	Day 15
Day 16	Day 17	Day 18	Day 19	Day 20
Day 21	Day 22	Day 23	Day 24	Day 25
Day 26	Day 27	Day 28	Day 29	Day 30

Challenge 22

The ways we speak to ourselves throughout the day greatly impact our feelings of self-worth, our belief in our abilities, and how often we take solid action in the direction of our goals. The unfortunate truth is it can be rare that we say things in our heads like, *"I totally got this," "I'm more capable than I realize,"* or *"I give myself permission to feel what I need to feel in this moment,"* when we're feeling overwhelmed or less than stellar.

Affirmations are defined as "emotional support or encouragement" and using them creates the action of affirming or reaffirming a belief. If you've ever been interested in or have practiced any mindset work, you might already know how powerful affirmations can be. Now, merely saying things to ourselves in the morning and then going on with the rest of our day won't have a very big impact but if you take time to truly let the affirmations soak in and they resonate with you, they can help you take inspired action aligned with your goals and desires. It's similar to reading a quote and feeling like "holy bananas that's exactly what I'm going through" but then never doing anything about the realization. For some reason saving quotes to my phones doesn't result in life-changing happenstance.

Practicing morning affirmations gives you the opportunity to re-frame the habits of how you might be speaking to yourself, and start believing in how powerful you actually are. They are also a great way to start setting intentions for how you want to feel throughout the day.

How to use affirmations:

- Find ones that speak to you, if they feel cheesy or don't feel aligned with who you are, they won't do you any good
- Read them multiple times, say them out loud if you want to. The more you hear them from yourself, the more they become truth.

Creating your own affirmations:

- Start with "I statements"
- Describe how you want to feel in the present moment
- Avoid stating what you don't want or are trying to avoid
- Frame them in the positive

Some affirmations to get you started:

- I have everything I need within me to get started
- I have a deep trust in myself that allows me to know where to go next
- My resilience is one of my greatest strengths

> ◑ *You can get started and discover 44 powerful affirmations that will be delivered straight to your inbox each morning on my website at* **SarahRoseCoaching.com/affirmations**

Calendar Tracker

Day 1	Day 2	Day 3	Day 4	Day 5
Day 6	Day 7	Day 8	Day 9	Day 10
Day 11	Day 12	Day 13	Day 14	Day 15
Day 16	Day 17	Day 18	Day 19	Day 20
Day 21	Day 22	Day 23	Day 24	Day 25
Day 26	Day 27	Day 28	Day 29	Day 30

Challenge 23

*S*ometimes it's all about getting back to the basics of self-care and sometimes that means flossing like a real full grown adult. Can we be real? Sometimes I'm not consistent with flossing and I need a hard reminder about how important it is. One of my favorite comedians, Mitch Hedberg, once said, *"It's as hard to quit smoking as it is to start flossing."* The man had a point. What is it about flossing that we collectively despise so much? Granted, it is one of the more meticulous parts of the daily routine...

The American Dental Association recommends flossing at least once per day but I'm challenging you to floss twice a day for some added reasons. First, flossing in the morning and in the evening will help you build on both your morning and evening routine which have been highlighted throughout other challenges in this journal and it can be helpful to have activities that mark the beginning and end of your day. These can serve as anchors for other habits, reminders of routines and schedules, and can help you to feel more confident about what you accomplish in the day. Yes, somedays it just feels good to know that you got your flossing in.

A few reminders for why it's important to floss:

- Brushing alone doesn't remove all plaque buildup which can harden and lead to tartar, gum disease, and cavities
- Flossing helps toughen up your gums (gums of steel!) and prevent bad breath
- Flossing helps clean the gaps between your teeth to keep bacteria parties from happening
- Flossing increases your IQ and makes you more approachable to mystical tree spirits (okay, this last one isn't true but who knows what might happen if you're consistent with this!)

Make flossing a part of your nightly routine by simply making it an add-on action. If there's something you already do each and every night without much thought, tack it onto the end of it. For example, I always set the coffee before I go to bed (because coffee is my spirit animal) and I know that it makes my morning amazing. Flossing immediately after that is a great way to make it happen without forgetting about it.

By doing something for 30 days you turn it into a habit, something that becomes effortless because it doesn't require you to put mental effort into it every time you do it.

Calendar Tracker

Day 1	Day 2	Day 3	Day 4	Day 5
Day 6	Day 7	Day 8	Day 9	Day 10
Day 11	Day 12	Day 13	Day 14	Day 15
Day 16	Day 17	Day 18	Day 19	Day 20
Day 21	Day 22	Day 23	Day 24	Day 25
Day 26	Day 27	Day 28	Day 29	Day 30

Challenge 24

Use Lotion Each Day

My name is Sarah and I collect smell good lotions and never use them. Are you this person, too? Once in a blue moon, I remember to use the lotions I have and the experience is always so nice. It's such a simple moment but I always feel so pampered and taken care of. I really don't know why I don't do it each day, which is why for 30 days, you will!

If you're prone to dry skin or dry knuckles in the winter, using lotion as part of your routine can be mega helpful. Using lotion (and drinking enough water, see challenge #18) can help prevent dry skin in the winter and thus prevent the awful burning sensation when you try to soothe your dry hands with lotion—what a cruel cycle! But even if it's summer, it can feel so luxurious to add it to your self-care practice. It's less about the lotion itself, and more about taking a moment to connect to your body. Ever notice that when you put lotion on your hands, legs, and skin there's a moment you where you check in with that part of your body? It's like saying, hey, how are we doing, legs? Maybe we need to stretch more, or I should take you for a walk. It also gives us an opportunity to check our skin for abnormalities, moles, or any other things we should be aware of. Skin health is important!

Using lotion can also be the perfect excuse to give yourself a massage. I worked as a bank teller one summer during college and was amazed (and upset) by just how bad my feet hurt at the end of the day. I started a nightly routine of using lotion on my feet and giving them a massage and it worked wonders!

Tips on how to give yourself a hand massage:

- Add a dime size amount of lotion in your palm
- Rub your hands together spreading the lotion on both the palm and back side of your hand
- Use your thumb for most of the work starting by moving it in circular motions around the edges of your palm
- Work in long, fluid motions and bring your thumb and pointer finger up pulling each finger gently
- Pinch the tips of each finger, slowly bending them back and forth
- Take a moment to apply pressure with your thumb to the "union valley" on the back of your hand, the fleshy area between your thumb and pointer finger. This is an acupressure point that can alleviate pain and calm you down
- Repeat with your opposite hand

Calendar Tracker

Day 1	Day 2	Day 3	Day 4	Day 5
Day 6	Day 7	Day 8	Day 9	Day 10
Day 11	Day 12	Day 13	Day 14	Day 15
Day 16	Day 17	Day 18	Day 19	Day 20
Day 21	Day 22	Day 23	Day 24	Day 25
Day 26	Day 27	Day 28	Day 29	Day 30

I remember during my Senior year of my Communications Degree, I took a class on website design. It was a CHALLENGE because the course was only offered Spring Quarter and it was from 6-8 p.m. in the evening—RIGHT when the glorious sun was shining down on the campus and everyone was outside. Not only that but the class was in the basement of the communications building, without any windows. It often felt like walking into a prison sentence but the class itself was a lot of fun. Long rant aside, I remember it being the first class where a professor told us to look up the answers to any questions we had on YouTube.

What? Really? We can do that and you're okay with that? His stance was that there were over 30 of us in the class and he couldn't possibly assist each of us with coding and layout/design questions. So off to YouTube land I went.

What it made me aware of (and this may be obvious) was that the internet is filled with so much more than funny cat videos and Facebook posts. There's a plethora of tutorials and knowledge out there that we are often overlooking.

For the next 30 days, I challenge you to make a list of things you want to learn, big or small. Whether it's how to spin a basketball on the tip of your finger, how to tune a guitar, how we digest bananas, how to bake without eggs, how big Earth is compared to Mars, or more details on the Donner Party (it's just so fascinating!).

After you've made your list, choose days to learn about all of these topics. Soon you'll be diving deep into the land of self-education and it will be a ton of fun. Plus, just think about how interesting you'll be at parties! Throughout this process you'll likely come across educational and entertaining YouTube channels you never knew about. Make a list of these as well. There have been channels I've enjoyed so much I often will watch them over shows on Netflix depending on my mood.

A few more topics to get your ideas flowing:

- Autobiographies about people you look up to
- The history of our transportation system (did you know that steam engines used to combust regularly on boats until they came up with an alternative!?)

Places besides YouTube to learn things:

- TED Talks (www.ted.com)
- Coursera—A resource of free MOOCs (massive open online courses) you can take from top universities

Calendar Tracker

Day 1	Day 2	Day 3	Day 4	Day 5
Day 6	Day 7	Day 8	Day 9	Day 10
Day 11	Day 12	Day 13	Day 14	Day 15
Day 16	Day 17	Day 18	Day 19	Day 20
Day 21	Day 22	Day 23	Day 24	Day 25
Day 26	Day 27	Day 28	Day 29	Day 30

When I started watching Grey's Anatomy I would always roll my eyes when Meredith and Christina had those random dance parties, but then again, when I have solo dance parties, they are REALLY FUN. Usually they go down after I've had a glass of wine, I'm halfway into baking brownies, and I decide to blast some dubstep. But it got me thinking, if I did these on the regular, I'd probably feel pretty damn good and every time they randomly happen, I always feel uplifted and motivated afterwards.

I can't stand it when I'm doing a workout video and someone else can see me, so you may feel this way about having a solo dance party. Make some time each day to either blast some music (at a reasonable level—let's not upset too many neighbors here) or wear headphones and boogie your booty into a feel good mood.

Having dance parties can allow you to loosen up, to smile, to let go of some of the routine and structure that can keep us from being silly and enjoying being in our body from a place of play. They can also serve as a great form of exercise, increasing our mood, cognitive functions, heart and lung health, muscle strength, and even our endurance. Plus, nothing gets the endorphins flowing faster than listening to sick beats that make us feel good and get us to move.

Not the kind of person who just starts dancing or knows how? That's totes okay. Sometimes I straight up watch dance or music videos with choreography I love and use that as inspiration. Other times I blast dubstep and let the bass take over.

Try not to set too many limits on where these take place and just let them happen. Dance while you're making dinner, cleaning, organizing your desk, or coming in the door. Make a playlist of songs that feel irresistible to dance to, let go of what other people might think, and get to shaking!

"The most common way people give up their power is by thinking they don't have any."

-*Alice Walker*

Calendar Tracker

Day 1	Day 2	Day 3	Day 4	Day 5
Day 6	Day 7	Day 8	Day 9	Day 10
Day 11	Day 12	Day 13	Day 14	Day 15
Day 16	Day 17	Day 18	Day 19	Day 20
Day 21	Day 22	Day 23	Day 24	Day 25
Day 26	Day 27	Day 28	Day 29	Day 30

*W*hen I was in high school I could not WAIT to get into my car or get back home to my room so I could listen to music. There's something very coming of age about music during our youth, it's a way of claiming our sense of self, our independence, and our own personality. It's like saying, I love rock and roll and I don't care if my parents hate it, in fact, it might be better if they do.

In college, my roommates and I would spend HOURS downloading songs, sharing music and artists. Freshman year was hands down the most abundant time of music in my life because it was coming at me from all angles. I found myself liking and even loving genres of music I'd never considered giving a chance before, like country. My world kind of turned upside down and my mp3 player turned into one of the most eclectic things I owned.

Over the last few years of my life, I've noticed that I haven't made as much time for music. For one, I'm not surrounded by dozens of people my own age on a daily basis and I'm also not walking across campus with an iPod Nano. Taking time to listen to music we enjoy can be one of the biggest acts of self-care. After all, the music we enjoy feels a lot like soothing sensations for the soul. We can't always explain why we love the type of music we do so much, it just makes us feel so inspired and happy about life.

Make time in your life for the next 30 days to listen to more of your music, whatever that may be. Whether it's songs from your past or new music you discover. Make some playlists on Spotify, call up old friends and reminisce about favorite bands. Go through your old mix tapes and CDs. I straight up have a mix cassette tape titled "Hot Hits" that starts with "Never gonna give you up"—you can't make this stuff up. See where music takes you and what it inspires you to do more of in your daily life.

*"I am not a product of my circumstances.
I am a product of my decisions."*

-Stephen Covey

Calendar Tracker

Day 1	Day 2	Day 3	Day 4	Day 5
Day 6	Day 7	Day 8	Day 9	Day 10
Day 11	Day 12	Day 13	Day 14	Day 15
Day 16	Day 17	Day 18	Day 19	Day 20
Day 21	Day 22	Day 23	Day 24	Day 25
Day 26	Day 27	Day 28	Day 29	Day 30

Challenge 28

Sitting in Nature

*I*n Challenge #12, we talked about the benefits of Shinrin-yoku or "forest bathing" and how spending time outdoors can improve your health and well-being. Sitting in nature allows us to do the same thing but can often be a powerful way to embrace the stillness of the moment and bring our minds back to the present.

Whether you are sitting in your backyard, a local park, or out on a hike in a National Park, sitting still in nature gives your mind the opportunity to rest, let go, and release tension and stress. In the book, *Your Brain on Nature* by Selub and Logan, they dive into the science behind the power of the natural environment and how even looking at a photo of nature can increase our sense of well-being.

By taking time to sit in nature, you heighten your awareness of both your surroundings and your internal dialogue. You may find that there are thoughts you haven't allowed yourself to fully explore, realizations that just needed a chance to be heard, of physical feelings within your body that give you ideas of how to take better care of yourself. For example, you may find that once you allow yourself to be present and still that anger shows up in your chest or that various emotions or feelings reside in different parts of your body. Sitting outside can also encourage you to live more mindfully and with more intention. I often notice that after I spend time outside I'm more clear on any worries, concerns, or issues I was facing. It feels easier to tackle whatever is on my mind and I find myself responding instead of reacting to frustrating situations as well as acting with a greater level of compassion. Notice what comes up for you after you spend time sitting outside.

Make a plan to spend at least 10 minutes sitting outside for the next 30 days. Even if you don't live near a remote natural setting, looking to the sky can have profound effects on your health.

" Never does nature say one thing and wisdom another. "

-Juvenal, Satires

)𝄞●● Calendar Tracker ●◖◗(

Day 1	Day 2	Day 3	Day 4	Day 5
Day 6	Day 7	Day 8	Day 9	Day 10
Day 11	Day 12	Day 13	Day 14	Day 15
Day 16	Day 17	Day 18	Day 19	Day 20
Day 21	Day 22	Day 23	Day 24	Day 25
Day 26	Day 27	Day 28	Day 29	Day 30

Pets provide us with a joy and abundance of love that feels unconditional, supportive, and warm. Cats have been shown to lower our blood pressure and many animals including dogs, horses, and rabbits have been used to provide emotional support to people with anxiety, depression, PTSD, and other mental health conditions.

If you have a pet, chances are you're cuddling on the regular already but you can take this one step further by making time each day to be in the moment with your animal. Instead of turning on the TV or scrolling through your phone, focus on providing attention to your pet and notice how you start to feel.

Albert Einstein once said, *"Everything in life is vibration,"* and animals are no different. When our pets feel at ease, they transmit a higher frequency of vibration which can in turn, affect our stress levels and make us feel good. Cats have been known to lower blood pressure and service dogs are often used in nursing homes to boost happiness and well-being in patients and residents.

I've experienced this in my own life with my bulldog, Bella, who was a huge support as I went through my own spiral of depression and anxiety. Knowing she was always there, always close to me, and always ready to "listen" was comforting. It also allowed me to feel good in taking care of another life, knowing the importance of support and loving kindness in everyday life. Animals seem to have an instinctual way of knowing when we need to be comforted, it's always made me wonder what areas of communication or senses they may have that we aren't as tuned into. Some days when I'm feeling low, Bella will cuddle closer to me and even lay on my chest. The weight of her feels comforting and when I look into her eyes, I feel heard. Maybe you've experienced something similar before, too.

If you don't have a pet, consider volunteering at an animal shelter. Many humane societies and shelters need people to regularly walk dogs and take care of animals. You can also house sit for a friend or ask to walk their dog each day for a month. Discover the benefits of animal therapy by making time to be present with an animal each day.

" The difference between friends and pets is that friends we allow into our company, pets we allow into our solitude."

-Robert Brault

Calendar Tracker

Day 1	Day 2	Day 3	Day 4	Day 5
Day 6	Day 7	Day 8	Day 9	Day 10
Day 11	Day 12	Day 13	Day 14	Day 15
Day 16	Day 17	Day 18	Day 19	Day 20
Day 21	Day 22	Day 23	Day 24	Day 25
Day 26	Day 27	Day 28	Day 29	Day 30

*L*ife can feel so crazy and chaotic that we can forget to reach out to past friends and current people in our lives. It only takes a moment to text someone yet sometimes we don't out of fear that it will seem out of the blue, inauthentic, or that it's not as good as a phone call or an in person visit. Small actions are better than no actions at all and I can tell you that reaching out to someone where there is mutual respect will be well received, even if it isn't under the "perfect" conditions. If it isn't, then that can be a bigger sign of the status of the friendship or relationship with that person.

For 30 days, reach out to someone in your life and let them know why they matter to you, why they are awesome, or why they bring joy to your life. It doesn't have to be long and it can be as simple as saying something like, *"I love that you're always here when I need someone to listen and I wanted you to know how much that means to me."*

It might help to make a list of people to reach out to or you may find that you want to text the same people over and over again throughout the month. Let them know the challenge you're committing to and share with them why you've chosen to text them. Chances are they'll feel pretty delighted that you want to say good things about them.

Reaching out to others and expressing your gratitude to them and for them is an act of self-care because it can remind us of how we are supported and the ways in which we give and receive love and support. It also helps us build that "gratitude muscle" or awareness around what we are truly thankful for.

Looking for ideas on where to start or what to say. Try these:

- Let someone know when you were last thinking of them and what reminded you of them
- Tell someone about something they made for you that you still have
- List off 3 things that make you smile when you think of them
- Remind them of an inside joke you both share
- Tell them about their qualities and personality traits you admire

"A real friend is someone who would feel loss if you jumped on a train, or in front of one."

-Anonymous

Calendar Tracker

Day 1	Day 2	Day 3	Day 4	Day 5
Day 6	Day 7	Day 8	Day 9	Day 10
Day 11	Day 12	Day 13	Day 14	Day 15
Day 16	Day 17	Day 18	Day 19	Day 20
Day 21	Day 22	Day 23	Day 24	Day 25
Day 26	Day 27	Day 28	Day 29	Day 30

*H*ands down one of my most favorite self-care activities. There's nothing like getting into a warm tub and soaking away the day. Bubble baths don't have to be hour-long endeavors, either. Even soaking for 10-15 minutes can be a great way to remind your body to calm down and activate your parasympathetic nervous system, the part of your nervous system responsible for "rest and digest" which lowers your heart rate and blood pressure. ::high five::

Taking a hot bath not only can help your body relax but it also has some pretty awesome health benefits to get you even more motivated. For example, regular baths can serve as a "workout" for your blood vessels and can increase oxygen flow and circulation throughout your body. Baths can also help you fall asleep easier by relaxing muscles and soothing away mental stress. Hot baths can help open up pores and clear the skin (and make razor burn a lot less likely). Ever feel super hot or cold and can't seem to shake it? Taking a warm bath can help regulate your body temperature rather quickly. I find this especially helpful on those cold winter days when no matter what I do, I can't seem to get warm.

Some tips for your bath times:

- If you're low on time, try a foot soak by only filling the bath up a few inches, you can also do a quick sitz bath, which can be a good way to feel fresh and clean clean ;)
- Experiment with different bath add-ins like bath bombs, essential oils, Epsom salts, and bubble bath concoctions

> ◖ BONUS TIP: *To uplevel your bath and hydrotherapy experience, try visiting a float tank or float spa. These are also known as sensory deprivation tanks and can be quite an experience if you are looking to deepen your mindfulness and meditation practice. Float tanks are composed of a high density of Epsom salts, typically around 800-1500lbs, making it impossible for anyone not to float. It's quite an experience and after a while, it can feel as if you are floating in a abyss of nothingness. This is also due to the fact that most float tanks are also dark and soundproof. From personal experience, it can be a bit trippy the first time. It took me 30 minutes to let go of strange thoughts and assumptions about the experience before I was truly able to relax and enjoy it. It's not uncommon for people to experience hallucinations, states of deep inner-calm, and even have new realizations during a float.*

)) ● ● Calendar Tracker ● ● ((

Day 1	Day 2	Day 3	Day 4	Day 5
Day 6	Day 7	Day 8	Day 9	Day 10
Day 11	Day 12	Day 13	Day 14	Day 15
Day 16	Day 17	Day 18	Day 19	Day 20
Day 21	Day 22	Day 23	Day 24	Day 25
Day 26	Day 27	Day 28	Day 29	Day 30

Back in challenge #25, I encouraged you to learn how to do something new or educate yourself on something of interest. This round, I'm encouraging you to spend 5-10 minutes a day watching funny videos.

Laughter is the medicine for the soul. One of my favorite ways to de-stress and feel good after a tough day is to watch Stand Up comedy or fun videos online. In fact, there are nights when instead of watching a movie or a show, my husband and I will watch a series of "Try not to laugh challenge" videos. They always help us feel in a better mood and we both end up giggling on the couch, what's not to love about that?!

Laughter also has some powerful benefits that serve as a great reminder to get your smile on and your belly muscles moving on a regular basis. Laughing helps us decrease stress hormones such as cortisol and relieve tension and stress. Laughter also releases endorphins, or all those feel good chemicals, into our body similar to when we exercise that leave us with a bit of a "high." Laughing can also improve our connection and bond with others and serve as a reminder of the simplicity and joys of having fun and being silly even as adults. Laughter can also boost your immune system as it releases powerful antibodies that can help ward off bacteria and viruses. Take that, common cold! Another amazing thing about laughing, especially for 15 minutes or more, is that it can increase our pain tolerance and act as a source of temporary pain relief. This is important not only for physical pain we may be experiencing but also emotional pain or wounds we may be facing.

As you find funny videos, write them down. Ask friends for their favorites and enjoy making more time to laugh each day.

Funny video and search ideas:

- Try not to laugh challenges
- Best of...funny cat, dog, animal videos

"Whether you think you can or you think you can't, you're right."

-Henry Ford

Calendar Tracker

Day 1	Day 2	Day 3	Day 4	Day 5
Day 6	Day 7	Day 8	Day 9	Day 10
Day 11	Day 12	Day 13	Day 14	Day 15
Day 16	Day 17	Day 18	Day 19	Day 20
Day 21	Day 22	Day 23	Day 24	Day 25
Day 26	Day 27	Day 28	Day 29	Day 30

Challenge 33

When I was little I remember my Mom saying *"Someday, we'll be able to see each other over a video when we talk instead of a phone,"* and my mind was blown. No way, I thought, that's so futuristic.

Now we actually have that capability and so many people don't use it. Which is crazy! The number one reason typically being, ugh my face will be on there. But truthfully, the people who love and care about you want to see your face, no matter how "bad" of a day you're having. There can be a lot of anticipation over a video that we don't necessarily experience in person.

There also can be a lot of anxiety over video conversations and I get it, I get nervous every time I do a Facebook LIVE in my group or a Webinar for my clients. But the more you do it, the less nerve wracking it becomes and the more fun you'll have because it really feels like you're "there" with the person you're talking to.

For the next 30 days, make a commitment to Skype or Facetime a family member or friend. It might mean you need to schedule out some times that work with everyone. Get a group together over a Google Hangout and get creative with what you do.

Even a 5 minute conversation with someone will make you feel like you caught up with them in real life and can be a powerful way to feel the connection with someone else. Plus, no one is going to judge your face or whatever is going on with your hair that day, people want to see you just like you want to see them!

Ideas for Skype and video convos:

- Do a house or apartment tour if you live in a new place
- Let your pets say hi, I love being able to see my Mom's cats when we do a call
- Get a stand or find a place to put your phone if you're using one so you can be hands free
- Use headphones with a microphone so you don't have to worry about hearing them or vice versa
- Get creative! Play a game, do something together that you both can do from your homes

Calendar Tracker

Day 1	Day 2	Day 3	Day 4	Day 5
Day 6	Day 7	Day 8	Day 9	Day 10
Day 11	Day 12	Day 13	Day 14	Day 15
Day 16	Day 17	Day 18	Day 19	Day 20
Day 21	Day 22	Day 23	Day 24	Day 25
Day 26	Day 27	Day 28	Day 29	Day 30

Challenge 34

Watch a Sunset or Sunrise

*E*very morning and every night this magical thing happens where the sun dips down under or rises up above the horizon and for many people, 365 of these days go by each year without them getting to witness a single one. ::sad face::

But that all changes this time around because for 30 days, you're going to watch at least one a day. Catching a sunrise can be a bit tricky if you're not a morning person but if you're also working on getting up earlier each day (see challenge #13) then you can combine the two— yes you can combine these challenges #whynot

Catching a sunset might also mean that you get a daily walk in during the evening or share it with someone you love. Instead of watching reruns of shows on Netflix, you could be out experiencing one of nature's most beautiful events!

Sunrises are a reminder of the powerful cycle and motion of earth each day. These things remain constant no matter what endless shifts and circumstances may be going on in our own lives. It can feel grounding and comforting to come back to the rhythm of these cycles within the earth at times, trusting that after each dark night there will always be a bright morning. The sun will always rise and the sun will always set.

Take a moment to consider other earthly elements and events that continually take place. Whether in nature or even in your own body. For example, as long as you are alive, you are breathing. For every breath you take in, you will exhale a breath back out. Noticing these subtle consistencies can be a mindful way of bringing yourself back to living in the present moment, which can make it a lot easier to let go of overwhelming thoughts and negative emotions.

The colors of each sunrise or sunset are determined by a number of factors such as scattering, or the variety of particles that interact with the atmosphere, as well as temperature, pollution, etc. Making time for 30 days to catch one of these natural phenomena can help you connect back to a state of purpose, and cultivate deeper forms of gratitude and awareness.

A few tips to help you get started:

- Make a commitment to how you will make time to take in a sunset or sunrise each day
- You may wish to get up early for half of the month or go on a walk in the evenings for the rest of the time
- Find out what time the sun is rising or setting in your area of the world by using an app like Daylight or by visiting www.sunrisesunset.com which will generate a full calendar for you

Calendar Tracker

Day 1	Day 2	Day 3	Day 4	Day 5
Day 6	Day 7	Day 8	Day 9	Day 10
Day 11	Day 12	Day 13	Day 14	Day 15
Day 16	Day 17	Day 18	Day 19	Day 20
Day 21	Day 22	Day 23	Day 24	Day 25
Day 26	Day 27	Day 28	Day 29	Day 30

Challenge 35

Whether you drink regularly or have the occasional glass of wine during ladies night, giving up alcohol for 30 days can allow you to connect to some of the reasons you may turn to alcohol in the first place.

Alcohol isn't all bad and if you're able to drink it intentionally and in moderation, awesomesauce. I'm always hyper aware of my alcohol intake since I grew up with an alcoholic father and I saw how quickly alcoholism and/or problem drinking can take hold of someone and their ability to show up in the world.

One reason I like to give up alcohol every now and then isn't because I think it's bad, but because it gives me an opportunity to check in with why I am drinking. Sometimes I'm having a beer just because and sometimes those "just because" feelings turn into habits or nightly beers.

Other times, I find that I'm buying and going through more wine because I'm stressed out or that I decide to have a glass of wine instead of handling a situation/problem/internal dilemma head on.

By giving up alcohol for 30 days you can see where your intentions lie and get back to a place of balance and harmony with any drinks you may be having. It can also be a great way to boost your health or make room for something else during your evening like tea, meditation, crafts, old school Roller Coaster Tycoon, or whatever it is you're into.

◗ Tips on dropping the alcohol:
- *Create a space in a journal, in a Word Document, or on your phone to write down why you really want a drink during any intense moments. You may find that it's actually your inner self reaching out for a feeling and not just a drink.*
- *Bring beverages you enjoy to any parties or gatherings you're attending so you can still hold something in your hand*
- *Ask the bartender for seltzer water and a lemon wedge or soda, many bars will serve you these types of drinks for free if you're the designated driver*

Calendar Tracker

Day 1	Day 2	Day 3	Day 4	Day 5
Day 6	Day 7	Day 8	Day 9	Day 10
Day 11	Day 12	Day 13	Day 14	Day 15
Day 16	Day 17	Day 18	Day 19	Day 20
Day 21	Day 22	Day 23	Day 24	Day 25
Day 26	Day 27	Day 28	Day 29	Day 30

I remember when photo challenges were more common when Facebook first started but there's no reason we can't bring them back now. Consider things in your life that bring you a lot of joy, whether it's your partner's smile, the morning fog, a salad you made, that look your dog gives you when he's ready for bed, or a family heirloom that you take out of storage.

Taking photos of things can be a great way to capture moments and also gives you an opportunity to declutter your life in a few ways. For example, when I'm considering getting rid of physical stuff in my house, I'll often take a picture of it before donating it. More often than not, I find that having the picture alone, is enough to give me that sentimental feeling and that the object itself isn't needed.

At the end of the 30 days, create an album for the photos you've taken. Write down why each one makes you happy and what was going on when you took it. Put them in a scrapbook or add them to a folder on your computer that you can come back to. You may also wish to share them on social media somewhere or have other people join in the challenge with you.

As you choose which photos to take and save each day, consider abstract and different ways of viewing happiness that you may not have considered before. For example, the photo itself may not instantly explain what about it brings you joy but you can use it as a jumping off point for diving deeper. An example of this might be a picture of a clean kitchen counter and how creating clear space in your home makes you feel mentally at ease as well.

Other photo ideas to get you started:

- Pictures of people in your life
- Moments when you feel especially happy or at ease
- A photo of yourself capturing a mood you are feeling or when you received good news
- Something in your life you accomplished or worked hard for such as a certificate, a promotion, or a degree

> *"I can be changed by what happens to me but I refuse to be reduced by it."*
>
> -Maya Angelou

)))●● Calendar Tracker ●●((

Day 1	Day 2	Day 3	Day 4	Day 5
Day 6	Day 7	Day 8	Day 9	Day 10
Day 11	Day 12	Day 13	Day 14	Day 15
Day 16	Day 17	Day 18	Day 19	Day 20
Day 21	Day 22	Day 23	Day 24	Day 25
Day 26	Day 27	Day 28	Day 29	Day 30

Challenge 37
Write Down One Thing Each Day That Makes You Laugh

I love it when I stay current on daily journaling and memory keeping, it can be so fun to look back on what was going on in my life and how much changed. The same thing can happen when you take time to write down the things that make you laugh.

So often my hubz and I will be like, *"Omg remember when such and such happened?!"* and then we'll both laugh infectiously for minutes on end. Just like challenge #32 where I asked you to watch funny videos each day, keeping track of things that make you laugh creates a bank of joy in your life that you can reference and come back to during difficult times.

Sometimes laughter can be the most important medicine we allow ourselves during some of the most difficult of life experiences. I was always amazed after I lost my father at age 23 how much laughing helped me move forward. Laughter serves as the reminder that we are alive, we experience emotion, and we have the ability to create instantaneous joy.

The things you write down don't have to happen in the same day but if they do extra bonus points your way. This challenge can serve as an opportunity to reflect back on things throughout your life that made you laugh and the moments you shared with others where infectious laughter took over.

Some things that have made me laugh recently:

- My bulldog being really upset that she "couldn't" come back inside from the deck because of the invisible door in front of her that was separating the living room from where she was
- When I was making a salad and beets slipped out of my hand and I said "I keep dropping the beets in here!" #dropthebass
- Those moments during meetings when you lock eyes with a colleague you're friends with and try not to laugh about nothing in particular

"Those who don't believe in magic will never find it."

-Roald Dahl

Calendar Tracker

Day 1	Day 2	Day 3	Day 4	Day 5
Day 6	Day 7	Day 8	Day 9	Day 10
Day 11	Day 12	Day 13	Day 14	Day 15
Day 16	Day 17	Day 18	Day 19	Day 20
Day 21	Day 22	Day 23	Day 24	Day 25
Day 26	Day 27	Day 28	Day 29	Day 30

Challenge 38

A while back I was inspired to try out a 10 day doodle challenge where you draw 10 small boxes in a journal or on a piece of paper and then draw something you love each day. I was surprised how fun it was and how capable I actually was of doodling even though I've never considered myself very artistic.

I am in NO way a "good" artist, in fact, I'm pretty sure if I put those on the fridge people would ask if my dog got into some colored pencils. What I did find however, was that it was a lot of fun and that I was capable of drawing more than I thought.

Doodling and drawing can be a great way to get into your zone of happiness. When we are focused in on a particular activity or moment, we feel more at ease. Keep in mind that your doodles don't have to amount to any one thing. They can be a series of lines, dots, and colors, or you can try your hand at drawing more complex or elaborate things. Sky's the limit here.

A study published in the *Journal of Cognitive Applied Psychology** found that people who doodle are more likely to daydream. Doodling can be a profound way to tap into your creative right brain, exploring more of your intuition, and stepping into ways of being that don't always require logic and reason.

Doodling also allows you to step into the moment, to create focused intention around one specific task which has been shown to increase happiness.

A few doodle ideas to help you dive in:

- Use the 30 day calendar and make a doodle in each section
- Write down a list of things you'd like to try drawing and try one each day
- Some ideas for doodles could be flowers, memories, coffee mugs, nature, animals, objects in your home, etc.
- Practice drawing lines and explore negative space (areas where you don't fill in on purpose)

> ◖ **Andrade, J. (2009). What does doodling do? Journal of Applied Cognitive Psychology, 24(1), 100-106. doi: 10.1002/ acp.1561*

"Doodling, by contrast, is beyond craft and criticism; it belongs to us all; it's impossible to do it badly—or well."

-Matthew Battles

Calendar Tracker

Day 1	Day 2	Day 3	Day 4	Day 5
Day 6	Day 7	Day 8	Day 9	Day 10
Day 11	Day 12	Day 13	Day 14	Day 15
Day 16	Day 17	Day 18	Day 19	Day 20
Day 21	Day 22	Day 23	Day 24	Day 25
Day 26	Day 27	Day 28	Day 29	Day 30

*W*hen I was 16, one of my good friends gave me a small notebook and I had no idea what I would do with it. I started writing down quotes and funny things that my friends said and before I knew it, I had my first Quote Book, often referred to as "THE QB!" It grew into pages and pages of quotes from friends, family, random acquaintances, strangers on the bus, and quotes I read or heard that made me feel empowered, motivated, or ready to try something new.

I often come back to it when I'm feeling nostalgic or need a good quote to inspire me. It's incredibly fun to have a special space to keep quotes, ideas, and inspiration that you can forever reference and share. I've even brought it to parties in the past and passed it around asking people to write down their favorite quote or saying.

Another fun aspect about writing down a quote each day is that it can become a part of your personal history. Many of the quotes in this journal of mine are from friends with the date they said them and what was going on at the time. Sometimes there's even more details about what it was referring to and sometimes it's so random I'm not quite sure what was happening at the time. Either way, there's nothing like texting up an old friend and saying, "Did you know you said this in 1997 at 4:03 pm?!"

You may find that even taking a few minutes every morning to look up quotes can help you feel empowered or inspired. Whether it's checking out Pinterest, Google, or even asking others for their favorite quotes, you'll be amazed at how quickly you fill up these 30 days.

Grab your own little notebook and for the next 30 days, take a moment to write down a quote you hear, a saying that resonates with you, or even something a friend says that you don't want to forget.

◑ Bonus ideas:
- *Write down quotes on post-it notes and stick them in public places for others to enjoy*
- *Write down the quotes you find on a whiteboard or place at work that gets high traffic (this is something I used to do at my desk each day and I became know as the "quote of the day girl")*
- *Text or email quotes you love that you think friends or family will enjoy and ask them to send one back to you*

Calendar Tracker

Day 1	Day 2	Day 3	Day 4	Day 5
Day 6	Day 7	Day 8	Day 9	Day 10
Day 11	Day 12	Day 13	Day 14	Day 15
Day 16	Day 17	Day 18	Day 19	Day 20
Day 21	Day 22	Day 23	Day 24	Day 25
Day 26	Day 27	Day 28	Day 29	Day 30

Challenge 40

Make Tea Before Bed

I am all about nightly routines and rituals and making tea is one of those things that says, *"Hey, I'm showing up for myself in this moment and doing something purely for myself."*

Making tea at night is also a great way to send a signal to your body that rest is fast approaching. There's a lot of talk about getting our mind ready to relax and end racing thoughts but it's also important to find ways to remind our physical body to calm down. Drinking warm tea is a tradition that goes back far beyond our history books. The cultural ways of drinking tea involve how tea is made, the way the water is boiled and poured, and how the tea leaves or ingredients are seeped in the water.

Tea has also been used for medicinal purposes in the past which still continues today. Different kinds of teas have many meanings and qualities that can support things like digestion, immune health, and even mood.

A few popular teas and their meanings/uses:

Chamomile—good for digestion and relaxation
Echinacea—good for for the immune system and helping with colds or sore throats
Ginger—can help relieve nausea
Peppermint—can help with stomach pain, cramps, and help with insomnia
Raspberry—good for uterine health

I have a giant stash of tea in the kitchen and always want to buy new kinds. It's such a cozy way to unwind and I often combine my nightly tea with journaling or meditation. Tea can also warm the body and make us feel relaxed, calm, at ease, and comforted.

Keep track of the teas you try, drink, and enjoy. You may wish to use the 30 day tracker to rate the tea you drink as well between 1-5. Consider how different kinds of teas make you feel or how they help relax or rejuvenate your mind and body.

◑ Tips on nightly tea drinking:
- *Make sure you find decaf teas*
- *Experiment with loose teas and new flavors*
- *Add lemon to your tea for an extra zing*
- *Set intentions as you pour and drink your tea*
- *Splash some almond or coconut milk in for added flavor*
- *Check the steep time for the tea you have chosen, some require more or less time for optimum flavor*

Calendar Tracker

Day 1	Day 2	Day 3	Day 4	Day 5
Day 6	Day 7	Day 8	Day 9	Day 10
Day 11	Day 12	Day 13	Day 14	Day 15
Day 16	Day 17	Day 18	Day 19	Day 20
Day 21	Day 22	Day 23	Day 24	Day 25
Day 26	Day 27	Day 28	Day 29	Day 30

Challenge 41

Write Yourself a Note for the Next Day

*O*ne of the main reasons why it can be hard to fall asleep is due to the fact that we worry we might be forgetting something. Or we go on mental tangents of to-do lists in our heads that we also know we could easily forget. One way to combat this is to write yourself a nightly note for the next day. A small list of things you need to consider or do, or even a note that you set by the coffee pot that says something as simple as, *"Today will be a wonderful day."*

You could even combine this with challenge #22 about morning affirmations and write yourself an affirmation to read to yourself the next morning.

Getting in the habit of writing your thoughts down at night can be a great way to tame the nightly mental chatter and allow your mind to peacefully calm down for deep and relaxing sleep. For example, you may find it helpful to use this note or writing time to reflect on the highs and lows of your day. Rarely do people take time to take pause at the end of a long day and reflect on what went well and what could have been better. Doing so can help ground your thoughts and help you evaluate what you might want to continue doing or change for the next day.

Sometimes I like to write notes to myself from two different voices or perspectives, challenging one or the other. For example, the first thought that might come to mind after a long day could be something like, *"I can't believe how little I got done, I feel so frustrated."* A way to turn this around could be writing something down next to it like, *"I didn't accomplish everything I wanted today but I did get the following things done."* Doing this allows you to open up your mind to the opportunities of new ideas and perspectives.

Other note ideas:

- Write down something you are proud of yourself for and want to remember
- Make a list of things you won't do such as saying "yes" to everything or letting traffic anger you
- Write down things you want to do with your free time—this can be a great list to come back to when the weekend rolls around ;)

"Nothing is a waste of time if you use the experience wisely."

-Auguste Rodin

Calendar Tracker

Day 1	Day 2	Day 3	Day 4	Day 5
Day 6	Day 7	Day 8	Day 9	Day 10
Day 11	Day 12	Day 13	Day 14	Day 15
Day 16	Day 17	Day 18	Day 19	Day 20
Day 21	Day 22	Day 23	Day 24	Day 25
Day 26	Day 27	Day 28	Day 29	Day 30

Challenge 42

There have been so many times in my life when I said, ENOUGH already, it's time to get rid of all the things! The problem was that this kind of urgent thinking left me without a solid game plan and resulted in me feeling overwhelmed and resentful of the entire experience. We're often more successful the more we break things down into smaller bite-sized pieces or chunks. It's a lot easier to do little things that add up to big breakthroughs over time.

When you start to feel like your home needs a little de-cluttering, it can be helpful to commit to getting rid of one thing each day instead of *everything* during a four hour window on a random Saturday. You'll also want to consider how or where you can donate it. Is there a friend you know who could use said item? Where is the nearest donation organization in your area?

Tips for knowing what to donate:

- Have you used it within the past year?
- What makes you want to hold onto it?
- If it's attached to a memory, would having a photo of it serve the purpose?
- Who would benefit more from it, you holding on to it, or someone else in need?
- What value is it bringing into your daily life?

Things to consider when you are wanting to get rid of items you own. Some items you may never use again, others you may use seasonally. Getting rid of things hastily can result in having to buy them again later or in not realizing how much you needed those boots when it rains. I've been guilty of this many times and it only added more frustration in the long run.

The things you decide to get rid of don't have to be big items, either. Start small and start in ways that allow you to be consistent throughout the 30 days. For instance, there may even be a handful of pens in that pen mug of yours that haven't been used in years, that's a great place to start!

As you near the end of the 30 days you may find it more difficult to find things to part with. If you're ever on the fence about something, try putting it in storage for a month first. This can be an easy way to see if you 1) ever think about it again or 2) find yourself needing it after it's moved.

Write down what you get rid of each day for the next 30 days and take note of how you start to feel in the process!

Calendar Tracker

Day 1	Day 2	Day 3	Day 4	Day 5
Day 6	Day 7	Day 8	Day 9	Day 10
Day 11	Day 12	Day 13	Day 14	Day 15
Day 16	Day 17	Day 18	Day 19	Day 20
Day 21	Day 22	Day 23	Day 24	Day 25
Day 26	Day 27	Day 28	Day 29	Day 30

Challenge 43

Knit or Crochet

Raise your hand if you have yarn hiding in your closet and a half-made scarf that's about 6½ years old. I for one, am mega guilty. I know how to knit a basic purl but still can't figure out how to crochet. For whatever reason, my motor skills can't handle it. I'm still going to keep trying, though.

If you've never ever knitted or crocheted in your life, it might be something fun to try. I love that it's something that took hold with the younger generation in the past decade and have always found that it's a great way to ease stress, anxiety, or intrusive thoughts. While I was in college in Bellingham, WA back in 2005, I spent a lot of time on the bus, waiting for the bus, and wondering where the bus was. To pass the time, I bought the biggest set of knitting needles that may have ever existed and started knitting afghans. They were not my best work but it was fun to complete one and give it to my Mom. (I hope she knows she doesn't have to keep them).

One thing that has kept me from knitting in the past is that I thought the outcome of whatever project I was working on wouldn't be good enough. I've knitted entire afghans that weren't really usable (again Mom, you really should get rid of those) but I had so much fun making them. Honestly, that's what it comes down to sometimes. If you're having fun in the moment with something, that's enough of a reason to keep doing it, even if it doesn't result in luxury handmade scarves you feel proud handing out for Christmas or beanies that you can give out to your running group for that winter half marathon.

Spend the next 30 days knitting or crocheting for 15 minutes a day. If you're still learning, use that time to learn. See what happens in 30 days of trying it out. Who knows, you might just be really good at it and if you're not, you can learn something in the process of trying out a new skill.

A few items you'll need to get started:

- Knitting needles
- Yarn you like the look and feel of
- A friend / book / or video to walk you through the process
- Movies or music to listen to while you knit

"A great part of health is the desiring of health. And a good sign of healing, to be willing to heal."

-La Celestina

Calendar Tracker

Day 1	Day 2	Day 3	Day 4	Day 5
Day 6	Day 7	Day 8	Day 9	Day 10
Day 11	Day 12	Day 13	Day 14	Day 15
Day 16	Day 17	Day 18	Day 19	Day 20
Day 21	Day 22	Day 23	Day 24	Day 25
Day 26	Day 27	Day 28	Day 29	Day 30

*A*dult coloring books—they are everywhere and they make me so happy! Funny story, I was in the grocery store a while back and I overheard an older man say, *"Why are these damn coloring books everywhere, even at the damn checkout!"* So grumpy, haha, but I have a feeling people love coloring books for a reason. I think they are everywhere because more and more people are discovering how stress relieving and fun it can be to sit down with a coloring book, some pens or colored pencils, and focus in on creating. Back in challenge #38 I told you a little bit about the benefits of doodling and coloring can help you achieve the same things as you zero in your attention.

It's one of those Zen ways of practicing mindfulness and it feels good when you see a page colored and completed even if there were mistakes along the way. Experiment with using different kinds of coloring tools, pens, and pencils. Doodle in coloring areas, practice unique shading, use different materials, or get creative in new ways. Whether you want to color on a blank sheet, find coloring books fun, or want to print out coloring pages online, getting started is the first step!

How to carve out coloring time:

- Bring your coloring book to work and color during meetings (ask your boss, of course) but knitting, doodling, and coloring can often provide a way for active minds to focus and pay closer attention.
- Keep a small coloring book in your purse or backpack. You can color anywhere! The next time you're waiting in your car, at the doctor's office, or for your friend to finish getting ready.
- Tie it to another ritual or routine during your day. Color at night as you drink your tea or make 10 minutes for it in the morning to help you wake up.

"Always be a first-rate version of yourself, instead of a second-rate version of somebody else."

-Judy Garland

Calendar Tracker

Day 1	Day 2	Day 3	Day 4	Day 5
Day 6	Day 7	Day 8	Day 9	Day 10
Day 11	Day 12	Day 13	Day 14	Day 15
Day 16	Day 17	Day 18	Day 19	Day 20
Day 21	Day 22	Day 23	Day 24	Day 25
Day 26	Day 27	Day 28	Day 29	Day 30

Challenge 45

*A*t any given time, there are 15-38 craft and project ideas floating around in my idea machine. Part of the reason I don't complete that many crafts is that I start one and then get really excited about another one. One way to ensure that you finish a project you enjoy working on and want to see to completion is to be consistent in little chunks throughout your day or week.

For the next 30 days, consider a project you've been wanting to start or have started that got put on the back burner. Devote a set amount of time to it each day for 30 days. This may mean that other things have to shift, like sitting on your couch for 90 minutes watching Instagram stories.

Before you begin, take a minute to list out any past projects you've wanted to complete or ideas you've had that you've never made solid time for. List them all out and then narrow them down to your top three favorites. From there take a few minutes to consider what each project would give you. How would working on them make you feel? How would the process involved bring you joy? What types of things would you be able to let go of while you worked on them?

A few tips:

- Write down your whys. Why do you want to work on this project? Why do you want to complete it? This will help you stay consistent.
- Consider how doing this instead of something else will contribute to your life in a positive way.

"Everything is theoretically impossible, until it is done."

-Robert A. Heinlein

Calendar Tracker

Day 1	Day 2	Day 3	Day 4	Day 5
Day 6	Day 7	Day 8	Day 9	Day 10
Day 11	Day 12	Day 13	Day 14	Day 15
Day 16	Day 17	Day 18	Day 19	Day 20
Day 21	Day 22	Day 23	Day 24	Day 25
Day 26	Day 27	Day 28	Day 29	Day 30

Challenge 46

Paint a Rock

Are you already thinking about how stupid pet rocks are? That's where my mind went when my Mom first told me about rock painting. But then I started looking into it and joined a Facebook Group all about rock painting and you guys, these people are serious.

And some of these rocks look like the actual things they are painting on them. There's some serious talent out there! I tried my hand at painting a ladybug that ended up looking like a bug infested tomato, but it was still a lot of fun!

Painting a rock each day or spending time on one over the course of several days allows you to again, be in the present moment, and work on new skills—a great way to get those neurons firing in new directions!

When choosing your rock it's important to consider the surface and how easy it might be to paint. Is it smooth or grainy? Is it a shape that will allow you to use a bigger brush or will it involve more intricate details? You can paint any rock you wish but giving thought to what you might want to paint and how focused you want the process to be will also help you assess what kind of brushes and supplies to use. Play around with how you want the rock to set on a table after it's completed, notice how it balances or wobbles and then choose which side to paint on.

Be mindful of where you take rocks from. You can't take rocks from any state or national parks and your neighbors might complain if they notice their rock garden slowly disappearing. You may also wish to clean and sand down your rock for a smoother look.

Acrylic paint works wonderfully on rocks and doesn't take too long to dry, either. Once you've painted a rock or two, give them a home, send them as a gift, or place them outside in your garden as a fun surprise for someone else to find.

Tips for you:

- Go on a rock hunting excursion. Find rocks around your neighborhood. Gather up a few when you go to the beach. Get yourself a little collection going so you have a few ways to start
- Write down ideas for rock painting.: animals, sunsets, words, colors or mandalas. There's no wrong or right way.
- Consider what you could use finished rocks for: paperweights, gifts, fun surprises to leave in parks or out in nature, or desk décor

Calendar Tracker

Day 1	Day 2	Day 3	Day 4	Day 5
Day 6	Day 7	Day 8	Day 9	Day 10
Day 11	Day 12	Day 13	Day 14	Day 15
Day 16	Day 17	Day 18	Day 19	Day 20
Day 21	Day 22	Day 23	Day 24	Day 25
Day 26	Day 27	Day 28	Day 29	Day 30

Challenge 47

*W*hen was the last time you had a massage? Massage can be one of the most relaxing ways to get in tune with your body and ease your mind but you might not always have time (or funds) to get them on a regular basis. One way to enjoy the power of massage on the regular is to give yourself a hand and foot massage. I know, it's way better when someone else is doing it and you can Zen out to aromatherapy and theta waves but this is the next best thing.

Back in Challenge #24 I shared some tips on how to give yourself a hand massage with one of the tips to press on the union valley or the acupressure point within the fleshy part of your hand between your thumb and pointer finger. Using a small amount of oil or lotion can help relax your hands and allow you to easily glide over the surface.

To start, bring the hand you wish to massage palm up, resting it on the fingertips of your opposite hand. From there, use your opposite thumb to begin applying pressure from the bottom of your palm upward. You may notice that even applying pressure with your thumb to your palm can start to make you feel relaxed. Work your way up your hand, slowly pulling each finger up and slightly away from your palm. If there's a specific area that feels tense, be mindful and spend more time and pressure there as needed. You can also slightly squeeze your fingers between your thumb and pointer finger as you move up.

To give yourself a foot massage it's important to be aware of the pressure points on the bottom of your feet. I'll walk you through two main ones to get you started.

1. The sole, or the area on the bottom of the foot underneath the ball of your foot, is an area that tends to hold a lot of tension. Applying firm yet comfortable pressure here can help you begin to relieve stress.

2. The instep, or pressure point on the top of your foot between your big toe and secondary toe where the bones meet. This area in acupressure is believed to help alleviate anger. So you know, the next time you're having an argument, try taking off your shoes and touching your feet. You may very well end the discussion altogether.

◑ Techniques for your foot massage:
- *Start by curling your toes*
- *Rotate your foot and your ankle in circles, or spell out your name*
- *Use the pressure points mentioned and then work your way out gradually into circular motions*

Calendar Tracker

Day 1	Day 2	Day 3	Day 4	Day 5
Day 6	Day 7	Day 8	Day 9	Day 10
Day 11	Day 12	Day 13	Day 14	Day 15
Day 16	Day 17	Day 18	Day 19	Day 20
Day 21	Day 22	Day 23	Day 24	Day 25
Day 26	Day 27	Day 28	Day 29	Day 30

Challenge 48

Watch a TED Talk

*W*hen I first discovered TED Talks, my life kind of changed. I really had no idea how many amazing individuals were out there and how vast their expertise was. From the science behind how we learn, how our perception of stress can affect our health, to topics about directed sound waves and future technology, the innovation never ends.

What is a TED Talk? If you check out their website at TED.com, they define it as:

"**TED** is a nonpartisan nonprofit devoted to spreading ideas, usually in the form of short, powerful talks. **TED** began in 1984 as a conference where Technology, Entertainment and Design converged, and today covers almost all topics— from science to business to global issues — in more than 110 languages."

Challenging yourself to watch a TED Talk for 30 days can do a number of things. It can help you create a more open mind, allow you to discover the abundance of innovation and limitless possibility that truly is before you, and it will make you the most interesting person at the next Super Bowl party.

While some TED Talks are 45 minutes or more, others are less than 10 minutes, making it incredibly easy for you to make time for them in your day. There's even an iPhone app. One of my favorite things about them as well is that their website provides the transcripts. So if you're caught up in an amazing presentation but don't want to take notes, you've got it all at your fingertips or you can read them if you're unable to watch or use sound.

Some of my favorite TED talks that I highly recommend:

Kelly McGonigal: *How to make stress your friend (14 minutes)*
Kelly shares how our perception of stress can impact our health

Brené Brown: *The power of vulnerability (20 minutes)*
Brené shares how stepping into and sharing our vulnerability can make us more resilient as well as what she's learned in her research

Andrew Soloman: *Depression, the secret we share (30 minutes)*
In this powerful talk, Andrew shares his experience with depression and how it really feels to live with it. This was a pivotal talk that helped me when I was deep in my own depression.

Calendar Tracker

Day 1	Day 2	Day 3	Day 4	Day 5
Day 6	Day 7	Day 8	Day 9	Day 10
Day 11	Day 12	Day 13	Day 14	Day 15
Day 16	Day 17	Day 18	Day 19	Day 20
Day 21	Day 22	Day 23	Day 24	Day 25
Day 26	Day 27	Day 28	Day 29	Day 30

Challenge 49

*H*ow often are you taking time to stretch? At least after every workout, right!? This is important! Stretching is one of the most overlooked fitness activities. I get it, you're TIRED after running two miles, lifting weights, doing that Turbo Kick jazz abs class, or maybe just playing Wii Tennis. But I'm here to tell you that stretching is one of the most important forms of self-care you can do.

Stretching has many benefits, is one of the best ways to prevent injuries, increase flexibility and balance, and decreases lower back pain. There's also been much debate about WHEN to stretch. Before you go show me your Google results on why your opinion is right, listen to what my dance instructor told me in high school: "Think about a carrot that's been in the fridge, you take it out and when you try to bend it, it snaps. But if you warm up the carrot, get it to room temperature, you'll find that it will bend more freely and not tear." Kind of hard to argue with that logic. This is why I truly believe it's best to stretch AFTER you workout. Don't get that confused with not warming up, because that's important as well. But if you bounce and pull your muscles before they're ready you're going to be sore and not in a good way. If you're wanting to stretch and haven't been super active in the day, take a moment to move your body, walk around the house, do a few jumping jacks, and loosen up your body.

When stretching make sure to take it slowwwwwly, hold each stretch and make sure to do them equally on both sides. If you can hold each stretch for 30 seconds or more, you will fully allow your body to ease into it.

Your challenge is to stretch for 10 minutes every day for the next 30 days. It may seem like a long time to sit on the floor but you'll be amazed at how much better your body will start to feel.

◖ A simple routine to get you started:

- *Begin standing and extend your arms wide side-to-side, bring them in toward your chest while still extended to cross your body. Alternate which arm crosses above the other. This is a great way to raise the heart rate slightly and loosen up your body.*
- *Extend one arm straight out in front of you and then bring it across your chest and hold. Repeat with the opposite arm.*
- *Tilt your neck slowly side-to-side, pausing, then drop your head down and rotate it around in slow circles.*
- *Stand with your feet together and slowly bring yourself forward reaching for the ground, don't over extend if it's uncomfortable.*
- *Sitting on the ground with legs extended straight in front of you, reach for your toes, hold.*
- *Spread your legs open and reach to each foot on each side, holding for 30 seconds.*

)))● Calendar Tracker ●●((

Day 1	Day 2	Day 3	Day 4	Day 5
Day 6	Day 7	Day 8	Day 9	Day 10
Day 11	Day 12	Day 13	Day 14	Day 15
Day 16	Day 17	Day 18	Day 19	Day 20
Day 21	Day 22	Day 23	Day 24	Day 25
Day 26	Day 27	Day 28	Day 29	Day 30

I'm still working on my yoga practice, in other words I'm far from having professional photos of me doing poses on various mountain tops. That's the first thing that I want you to remember though, that yoga is a practice, not a destination, not some perfect goal to achieve, it's a time to connect your mind and body, improve your flexibility, and allow the flow of energy through you.

I'm hesitant to give you any one specific definition of yoga, as there are many and I don't believe there is one right way to describe it so I'll define it in a way that I relate to, and maybe you will as well.

Yoga is the practice of connecting your mind, body, and spirit. It's the process of stepping into and trusting your intuition, developing a deep awareness of your true, core self, and embracing the flow of daily life.

Feel free to add to this definition or change it, I've provided space below for you to come up with your own definition of your yoga practice as you complete this challenge.

Your yoga definition: _____

Getting started with daily yoga is something that will be completely unique to you and your lifestyle. There are a myriad of free yoga videos online that you can use to get started and bring structure to your practice. Over time you will be able to work in your own yoga "flow" or the ways in which you move from one pose into another. Remember that within each pose you can move, sway, adjust, or find what's comfortable to you. I find that there are often spots that hold more tension than others and it can feel good to stay a bit longer with those areas.

◑ A few items you'll want for your practice:
- *A yoga mat*
- *Comfortable clothing that will allow you to move freely and that won't fall or hinder your poses as you move*
- *Soothing music or music that allows you to feel in the present moment*
- *A water bottle*
- *Patience, curiosity, and self-love*

" Every morning you wake up to an opportunity to change your situation. Don't waste it. "

-Angie Nelson

Calendar Tracker

Day 1	Day 2	Day 3	Day 4	Day 5
Day 6	Day 7	Day 8	Day 9	Day 10
Day 11	Day 12	Day 13	Day 14	Day 15
Day 16	Day 17	Day 18	Day 19	Day 20
Day 21	Day 22	Day 23	Day 24	Day 25
Day 26	Day 27	Day 28	Day 29	Day 30

Challenge 51

*E*ver meet that person that speaks with an eloquence and vocabulary that makes you feel instantly drawn to them? Or maybe you are that person. Either way, learning a new word every day can be a great way to not only improve your communication skills but also allows you to step into a deeper awareness of yourself, the world around you, and the kinds of observations you make. Language is a beautiful gift and an art that many take for granted. We are not only able to collaborate with others this way but we're also able to express our emotions, experiences, deepest desires, and pure joys. It's one of the reasons I always find myself fascinated when another language has a word for something I've never quite known how to express.

Take the German word, *Gemütlichkeit*, for example, which means the act of feeling warm, cozy, and connected not only under a blanket and with hot tea but also from the heart. This word is more of a description of a feeling than a tangible action, which makes it that much more alluring and wonderful.

Or the Japanese word, *natsukashii*, which means, *"Of some small thing that brings you suddenly, joyously, back to fond memories, not with a wistful longing for what has past, but with an appreciation of the good times."*

A few other English words that you may not have heard before:

- Ethereal (adj.)—extremely delicate, light, not of this world
- Oblivion (adj.)—the state of being unaware of what is happening around you
- Mellifluous (adj.)—a sound that is sweet and smooth, pleasing to hear
- Limerence (adj.)—the state of being infatuated with another person
- Syzygy (n)—an alignment of celestial bodies
- Ineffable (adj.)—too great to be expressed in words

Learning a new word might not be the first thing you consider when you think about self-care. However, building awareness and learning new ways to express ideas, thoughts, experiences, and dreams will bring you closer to your higher self and your ability to create connection with others. You may also find that many words are familiar yet their definition to you is new.

Each day for the next 30 days, write down a new word you find, what it means, and then try to begin incorporating it into your vocabulary, through your writing, with friends, etc. See how language can begin to open and transform your life (and impress people along the way).

P.s. Check out the Tumblr account *other-wordly* for amazing suggestions.

Calendar Tracker

Day 1	Day 2	Day 3	Day 4	Day 5
Day 6	Day 7	Day 8	Day 9	Day 10
Day 11	Day 12	Day 13	Day 14	Day 15
Day 16	Day 17	Day 18	Day 19	Day 20
Day 21	Day 22	Day 23	Day 24	Day 25
Day 26	Day 27	Day 28	Day 29	Day 30

Challenge 52

Eat Meals Without Your Phone or TV

*I*n this fast-paced life it's not uncommon to eat mindlessly. There's an amazing book by Brian Wansink called Mindless Eating where he walks us through the studies he's done that show the nature of our brains in response to food and eating patterns that happen within our society. You may be familiar with his famous study that showed how people will eat large portions of stale movie theater popcorn while they are watching a movie versus when they are eating it at a table focused on nothing else. In fact, many of them didn't even realize it was stale at the movies!

Now mindless eating isn't always a bad thing. Sometimes we have to eat on the go or have very little time to fuel up before a presentation or meeting. The problem arises when mindless eating becomes a habit and the experience of eating goes unnoticed. When we are unaware of how we are eating, we don't fully grasp the taste, texture, mouthfeel, and complete experience of eating a specific food. If you ever check out The Center for Mindful Eating (thecenterformindfuleating.org) you'll find a variety of resources and information on how eating mindfully can benefit both your physical and mental health.

So what does it mean exactly to eat mindfully? Eating mindfully means to be fully present with your food. In other words instead of eating chips out of the bag, you may put them in a bowl, sit with them on the couch, savoring each one, tuning in to your level of satisfaction with them, instead of mindlessly wondering where the entire bag went. I'm so guilty of this, by the way.

For 30 days, I challenge you to eat at least one meal without distraction. This means to be fully engaged with the food in front of you. To notice how it smells before you take the first bite. To consider how it appeals to you from an aesthetic level—does it entice you merely by the way it looks? To turn off the TV, put away your phone, and enjoy the experience of eating. Zeroing in on the process of eating can help you bring awareness to your level of satisfaction, fullness, and how much you may or may not enjoy specific foods. It also allows you to build awareness with what types of foods fuel you for longer and which ones may make you crave additional food or affect your energy level.

"I've climbed a few mountains. The climb sucks. It's hard. It hurts. But as soon as you get to the top of that mountain the beauty around you makes all those struggles disappear."

-Miss Mazuma

Calendar Tracker

Day 1	Day 2	Day 3	Day 4	Day 5
Day 6	Day 7	Day 8	Day 9	Day 10
Day 11	Day 12	Day 13	Day 14	Day 15
Day 16	Day 17	Day 18	Day 19	Day 20
Day 21	Day 22	Day 23	Day 24	Day 25
Day 26	Day 27	Day 28	Day 29	Day 30

Challenge 53

30 day nap challenge! Who's with me?! When I was a kid I hated naps with all my being. It was the ultimate punishment even when it wasn't intended to be. How could adults actually enjoy going back to sleep? I just didn't get it. Then during my undergrad, naps seemed essential. Naps between classes, naps after late nights of studying (and sometimes drinking). I couldn't seem to get enough naps, but that was also because I wasn't getting enough sleep in general.

When I was working in downtown Seattle years ago I became a semi pro at taking naps on the bus. I would fall asleep for 10-20 minutes on my commute to and from work and found that they majorly improved my mental function and energy. The key was not falling into a deep R.E.M. sleep or rapid eye movement sleep. This is where our brains go into a deeper sleep and where dreams occur. The only "problem" with R.E.M. sleep is that if you wake up in the middle of it, it's very hard to get going. You may have experienced this after taking a long nap or when getting up at a new time in the morning. Feelings of extreme fatigue and grogginess can occur even if you've gotten a full night's sleep. It's one of the reasons sleep apps can be helpful for attempting to wake you up after you've completed a R.E.M. cycle.

Power naps take practice. It can take a while to train both your brain and your body to relax, quiet down, and fall asleep, especially in the middle of the day or at a time where you're regularly being active or busy.

Taking a power nap can be a powerful way to boost your creative problem solving, giving you more mental energy and brainpower to solve problems or work on a big project or task.

If you can't take a nap at work, consider finding a place to take a 10-30 minute nap during your commute (as long as you're not the one driving, of course), or even quickly after work.

"Mistakes are a part of being human.
Appreciate your mistakes for what they are:
precious life lessons that can only be learned the hard way."

-Al Franken

Calendar Tracker

Day 1	Day 2	Day 3	Day 4	Day 5
Day 6	Day 7	Day 8	Day 9	Day 10
Day 11	Day 12	Day 13	Day 14	Day 15
Day 16	Day 17	Day 18	Day 19	Day 20
Day 21	Day 22	Day 23	Day 24	Day 25
Day 26	Day 27	Day 28	Day 29	Day 30

This may not be possible for everyone but get creative if you can. The workforce these days spends even more time and money getting to work than ever before. According to a CNN poll back in 2016, the average US citizen spends 45 minutes getting to work. It's even as high as 73 minutes for New Yorkers! Yikes! That's a lot of time to be sitting in traffic getting frustrated with taillights.

Consider what might change with your health and mental well-being if you got to work another way for 30 days. What if you had time to read, listen to podcasts, knit, or draw in adult coloring books? Maybe you could even take care of a few work emails before you get to work to help with your daily productivity. If driving is your only option, consider how alternating driving or using a carpool might help you. What would change if you didn't have to drive even 2-3 days out of the week?

There's also the other more obvious benefits of getting to work in alternative ways. For example, biking or walking to work would provide you with a built in workout each morning. If you can't walk to work completely, how far is the nearest bus stop? Additionally, you could choose to drive to a new location a bit further away from work or at the perimeter of a giant parking lot. Find ways that you can change up your commute and improve your overall health.

Find people that may be interested in doing this challenge with you or ask your Human Resources or Wellness Team if they have a designated month to encouraging employees to get to work in alternative ways. You may find that taking the bus or train could also lower your annual commuter costs.

If you don't work a 9-5 that requires you to travel every day, consider ways to create a "morning commute" that gets you more active or provides you with some time to ease into your day. For example, I work from home running my own business but feel the best when I make time in the morning first thing to get my steps in, do some reading, or meditate. Your "daily commute" can be anything you want it to be even if it means getting coffee with colleagues, other friends, or joining a regular group fitness class.

" Life is not a problem to be solved, but a reality to be experienced."

-Søren Kierkegaard

Calendar Tracker

Day 1	Day 2	Day 3	Day 4	Day 5
Day 6	Day 7	Day 8	Day 9	Day 10
Day 11	Day 12	Day 13	Day 14	Day 15
Day 16	Day 17	Day 18	Day 19	Day 20
Day 21	Day 22	Day 23	Day 24	Day 25
Day 26	Day 27	Day 28	Day 29	Day 30

Back in challenge #7, I encouraged you to spend 30 days writing a letter to someone each day. In this challenge I'm bringing in the same components but also combining them with expressing gratitude for others. There are things others do for us often, daily, or out of the blue that we often forget to thank them for or even acknowledge. For me, it's not always thanking my husband for doing the dishes or taking out the trash. The man does these things all the time without me ever having to ask or remind him. It's beautiful.

But beyond saying "thank you" or "I really appreciate that" every now and again, it can make an even bigger impact when I take the time to write him a thank you note or card. Sometimes I hide them in his pillow, throw them in his gym bag, or hand him one out of the blue. It never seems to get old and it always brings a huge smile to his face.

The same thing happens when I send random thank you notes to friends, family, or past coworkers letting them know I'm still thankful for something they did in the past and the lasting impact they had on me.

Thank you cards and handwritten notes are powerful forms of expression and gratitude and for the next 30 days, you're going to send some love and light to those around you who might just have no idea how much they've impacted your life. After all, it really is the little things we all do for one another on the daily that changes our world.

◐ Some thank you card ideas & prompts to get you started:
- *A few years ago you told me and it still impacts me today.....thank you*
- *I'll never forget how you made me feel when you....*
- *Last week you took the time to even though you were it meant a lot to me*
- *Every time you I'm overwhelmed with joy and appreciation that you're in my life*
- *Do you remember when I was and you helped me by thank you*
- *Thank you for saying when I really needed to hear it*
- *The meal you made the other night was amazing, I'm still dreaming about it*

"Don't let anyone ever make you feel like you don't deserve what you want."

-Heath Ledger

Calendar Tracker

Day 1	Day 2	Day 3	Day 4	Day 5
Day 6	Day 7	Day 8	Day 9	Day 10
Day 11	Day 12	Day 13	Day 14	Day 15
Day 16	Day 17	Day 18	Day 19	Day 20
Day 21	Day 22	Day 23	Day 24	Day 25
Day 26	Day 27	Day 28	Day 29	Day 30

I love trying to get in a walk each day, especially out in nature. Now, the weather doesn't always cooperate, but the experience is an adventure rain or shine. Back in challenge #12 I shared with you a little bit about the Japanese practice of Shinrin-yoku or "forest bathing" and how it can benefit your health, mood, and immune system. The big key component when it comes to forest bathing is being distraction free. It's why for the next 30 days, I'm going to challenge you to go on a daily walk sans phone or electronic device.

You might be thinking, "But Sarah! I love my music/podcasts/audiobooks!" I hear you loud and clear but even if you take 10 minutes to talk a walk without any of those things you'll bring in some badass mindfulness and self-awareness that will allow you to enjoy all of those things even more.

The thing is, and I'm totes guessing here, you might not get a lot of alone time with your thoughts. It might even be slightly uncomfortable for you and I'm not judging but I'm encouraging you to take the time to build those self-awareness muscles. Taking time to be with your thoughts and only your thoughts can help you reclaim control over a variety of areas in your life. Whether it's turning to food or alcohol to avoid unpleasant emotions, or finding yourself reacting more strongly or impulsively than you'd prefer when you feel frustrated.

As you walk without your phone you may find some anxious thoughts appear:

- What if I miss a phone call?
- What if something happens and I can't make a call?
- There will always be an endless stream of "what ifs."

If you're in a place where walking without your phone is completely unsafe, then by all means, take it with you and keep it in your pocket. The key here is really to take a walk free of distractions, so turn the volume down and your notifications off. Never put yourself in a dangerous situation, finding a safe and comfortable place to walk is important!

Notice what comes up for you when you're with your thoughts. Where does the resistance show up? Are there areas of your life you try to avoid thinking about. Take this time to really dive deep into self-exploration.

> "In every success story, you will find someone who has made a courageous decision."

-Peter F. Drucker

Calendar Tracker

Day 1	Day 2	Day 3	Day 4	Day 5
Day 6	Day 7	Day 8	Day 9	Day 10
Day 11	Day 12	Day 13	Day 14	Day 15
Day 16	Day 17	Day 18	Day 19	Day 20
Day 21	Day 22	Day 23	Day 24	Day 25
Day 26	Day 27	Day 28	Day 29	Day 30

Challenge 57

Challenge 57 *Sweat*

\mathcal{S}ometimes a simple goal is the best goal. There are days when I remind myself that my workouts don't have to be perfect, they just have to be something. I often say "it's not all or nothing, it's all or something." In other words, if you find yourself in a pinch to make the time for a workout in your day, find another way to sweat, even if it's only for 10 minutes. Getting your heart rate up and your body sweating is a good indicator that your muscles are being challenged and your cardiovascular system is being pushed. I spent a lot of my younger years running 6+ miles a day and sweat I did but I was surprised as I tried new forms of movement and exercise how much different things made me sweat as well.

Even slow moving yoga poses can get your heart rate up and your sweat going. Sure, it may not be the same heart pumping cardio as running, but your body is still benefiting from the experience.

This brings us back to the importance of setting smaller, tiny or micro goals that you can build on over time. If you're having a hard time committing to a specific workout video, exercise routine, or class, it might be helpful to commit 10 short minutes each day to getting your sweat on. Your challenge here is to decide when those 10 minutes will take place and to make sure you are good and tired. The motivation and encouragement you'll find from pushing and challenging yourself will lead you to working out harder, longer, and in new ways if you stick with it.

You really don't need any special equipment to make this happen, either. Using your own body resistance is more than enough to get you started. Make a list of exercises you want to do each day and create your own HIIT (high intensity interval training) workout.

Here's a sample routine:

- 30 seconds of jumping jacks
- 10-20 pushups (regular or on your knees)
- 30 seconds of "jump rope"—use an invisible one to start ;)
- 25 squats
- 20 leg lifts on each side
- 30 seconds of jumping jacks
- Repeat x3

Another idea that I've tried before is assigning a movement to each suit of a deck of cards. For example, hearts = jumping jacks, spades = squats , clubs = plants, and diamonds = high knees. See how far you can go through an entire deck of cards.

120

Calendar Tracker

Day 1	Day 2	Day 3	Day 4	Day 5
Day 6	Day 7	Day 8	Day 9	Day 10
Day 11	Day 12	Day 13	Day 14	Day 15
Day 16	Day 17	Day 18	Day 19	Day 20
Day 21	Day 22	Day 23	Day 24	Day 25
Day 26	Day 27	Day 28	Day 29	Day 30

Challenge 58

Go to the Local Pool

When I was younger there was nothing more exciting than Mom taking us to the pool. My brother and I would scheme for days on end it felt like trying to find the perfect way to ask her to take us. Even better was a Friday night sleepover with a friend that included pool time. Something about pools, man, we could spend hours on end keeping ourselves entertained. But as I grew up, I became a lot more body conscious, something I'm still working on and the pool took on a less than exciting feel. No longer was it about raiding the pool stock closet for floaties, flippers, and dive sticks, it was about other people seeing my body in a swimsuit and all the magic faded away.

Challenging yourself to get to the local pool can do a few things. It can bring back the nostalgia of that chlorine air and add a little fun to your days, but most of all it encourages you to be proud of your body and start to challenge any ways you may feel uncomfortable in a bathing suit. I know what you might be thinking and I'm right there with you having the same thoughts. Merely going to the pool isn't going to make me fall in love with my body instantly, but hey, it could help, couldn't it?

Take a moment to consider how many things you haven't done in your life because of your body. If it's zero and you've always been in love with your shape and size, I'm smiling HUGE for you! I wish we all could feel that way. But if you're anything like me, you may have said no to things in the past, told yourself that you didn't "deserve" to go because you weren't the size, shape, or weight you wanted to be.

Life doesn't start at a "perfect" weight. Life is happening right now, in this present moment, and it won't keep waiting for you. Experiences and opportunities fade away. We assume we have all the time in the world until we don't.

You don't have to love your body before you do things. You don't even have to feel completely comfortable. Challenging yourself to go to the pool for fun, for exercise, or for body confidence is powerful and trust me babe, you got this! I know you know this, but everyone there is thinking the same things you are, "Do people think I look...?" Owning your truth means owning your shape, your size, and your ability to do things you want to do. So go out there, get to that pool, and have some fun!

"Always live up to your standards—
by lowering them, if necessary."

-Mignon McLaughlin

Calendar Tracker

Day 1	Day 2	Day 3	Day 4	Day 5
Day 6	Day 7	Day 8	Day 9	Day 10
Day 11	Day 12	Day 13	Day 14	Day 15
Day 16	Day 17	Day 18	Day 19	Day 20
Day 21	Day 22	Day 23	Day 24	Day 25
Day 26	Day 27	Day 28	Day 29	Day 30

Challenge 59

Drink Green Tea

Quite frankly you could drink any type of tea you want for 30 days and enjoy the experience but let's talk about green tea for a moment. Green tea has flooded the interwebs for a long time now, boasting health benefits and medicinal qualities. After a while it almost seems like a hoax. But I'm here to tell you that green tea really is pretty amazing and if you don't mind the taste there are some pretty good reasons why drinking it every day could benefit your health and mental well-being.

A 2006 study* showed that one of the active ingredients in green tea, L-theanine, can increase GABA, serotonin, and dopamine levels in the brain. Dopamine is a neurotransmitter that fires between neurons giving us that rewarding feeling; something we experience when we go for a run or eat an enjoyable food. Serotonin is also a neurotransmitter that can affect mood, digestion, social behavior, and more. Typically serotonin used by the brain must be produced within the brain but there are various studies which suggest that the combination of tryptophan and certain foods can allow it to cross the blood brain barrier.

Drinking green tea also contains antioxidant properties which have been shown to help lower the growth or rate of growth of cancer cells. No one thing can necessarily be isolated to protect or heal us as our bodies are the sum of a multitude of parts and functions. In other words, you could drink green tea every day but if you're smoking or eating unhealthy, it won't protect you from the outcomes of those other lifestyle choices.

Getting the full tea drinking experience:

I know having a cup of tea sounds like a simple accomplishment but when we attach meaning and ritual to small activities they can feel worlds more beneficial, special, and even healing. Create a sacred time to have your green tea each day, maybe it's first thing in the morning. Choose a mug that calls to you, one that feels comfortable in your hands, and enjoyable with each sip. Sit in a place where you feel comforted, relaxed, and present. Take a moment to watch the heat rise up from the warm tea, visualize it giving you energy and comfort. As you take each sip, take a moment to notice how it feels drawing down your throat and into your belly. Imagine it warming your heart as well as your body. Take a moment to consider what you're grateful for and take your time drinking your cup of tea.

*Nathan, P., Lu, K., Gray, M., & Oliver, C. (2006). The neuropharmacology of L-theanine(N-ethyl-L-glutamine): a possible neuroprotective and cognitive enhancing agent. Journal of Herbal Pharmacology, 6(2), 21-30. Retrieved from https://www.ncbi.nlm.nih.gov/pubmed/17182482

Calendar Tracker

Day 1	Day 2	Day 3	Day 4	Day 5
Day 6	Day 7	Day 8	Day 9	Day 10
Day 11	Day 12	Day 13	Day 14	Day 15
Day 16	Day 17	Day 18	Day 19	Day 20
Day 21	Day 22	Day 23	Day 24	Day 25
Day 26	Day 27	Day 28	Day 29	Day 30

Challenge 60

Start Your Morning With a Green Smoothie

Green smoothies have changed my life. I know, that sounds a bit extreme but it's true! I used to think people who drank them were a tad extreme—who in their right mind loves spinach and kale that much?! But then I started making them for myself and my energy skyrocketed. If you've never had a green smoothie I'm here to ease any concerns about them tasting like purified spinach. In fact, I've never tasted the greens I've put into my smoothies, the key is using the right ratio of greens, liquid, and fruits.

Whether you want to start off your day with a green smoothie or have one at lunch or as a snack, I can tell you that having one a day for 30 days will make an impact on how you feel, even if you're not perfect with other habits.

Before you commit to 30 days, consider your "why" for wanting to drink a smoothie each day. I've often jumped into challenges simply because I want to be able to say I did them, and while admirable, they become difficult when I didn't have my own personal reason for staying consistent. Maybe you want more energy, more daily nutrients, or more whole foods in your diet each day. Make sure to not only mark down each day that you have a smoothie but also take note of how you start to feel.

◗ A few smoothie making tips:
- *Add in your liquid and greens first and blend until smooth. This will help you to avoid any "chunks" of spinach, kale, or whatever you decide to use.*
- *For the love of God, don't use arugula as your base green. I made this mistake early in the game and I still make the same disgusted face when I think about how bitter that blueberry smoothie was.*
- *You can totally use frozen spinach! I don't know why it took me so long to realize this but it's a lot cheaper to buy this way and will keep much longer.*
- *If you want to try adding in chia seeds, ground flax meal, or any other smoothie add-on, make sure it goes on top and not in the bottom in the order you add things into your blender. There's nothing quite as annoying as trying to get dried chia seeds out from under the bottom of the blade.*

PB Banana & Greens
- 1 cup water
- 2 cups spinach
- 2 frozen bananas
- 1 TBSP peanut butter

Directions: Add water and spinach to blender and blend until all chunks are gone. Add in bananas and peanut butter. Add more water for desired consistency if needed. Serve with raspberries or strawberries on top.

Tropical Blend Smoothie
- 2 cups water
- 2 cups spinach
- 1 room temperature banana
- 1 cup frozen mango
- 1 cup frozen pineapple

Directions: Blend the spinach, water, and seeds first to ensure you don't have any leaf chunks. Then add in fruit. Blend until smooth and pour into your favorite glass or mug.

Calendar Tracker

Day 1	Day 2	Day 3	Day 4	Day 5
Day 6	Day 7	Day 8	Day 9	Day 10
Day 11	Day 12	Day 13	Day 14	Day 15
Day 16	Day 17	Day 18	Day 19	Day 20
Day 21	Day 22	Day 23	Day 24	Day 25
Day 26	Day 27	Day 28	Day 29	Day 30

Challenge 61

This type of challenge would have been a "no-go" for me a few years ago. As I'm writing this I'm wearing makeup for the first time in weeks and nowadays I rarely wear any makeup at all. I even go run errands sans makeup ::gasp:: Some of you may be rolling your eyes but this was a pretty big deal for me. In my early 20s I always felt like my beauty was because of my makeup and wouldn't leave the house or even go to the gym without something on my face.

Drinking more water and eating a whole foods plant based diet has drastically improved my skin but I also don't seek that external validation anymore and know that it's not my job to look any one way as a woman.

Going 30 days without makeup may or may not be a drastic shift for you. I remember in high school if I went into class without concealer my teachers thought I was dying (I'm mega pale) so I would always make sure to wear it after that. But now I embrace my paleness and anyone who makes rude statements can go step on a Lego.

If you're reading this thinking, *"Yeah there's no way I'm doing this,"* then I instead, encourage you to go with less. Maybe this means no lipstick, mascara, or eye shadow. This challenge isn't because I think makeup is bad or that women should wear less, it's to help you get in touch with your inner beauty and realize how beautiful you are as you are.

It can also be fun to look at it as a social experiment. Each day you go without makeup, keep a log of what you do, where you go, and how people react. People close to you may make comments and on the other hand you may find that strangers don't pay any attention. Ultimately it allows you to consider how your perception of yourself is projected onto others and helps you look inward to see how you truly and honestly view yourself.

"If you feel beautiful, then you are. Even if you don't, you still are. "

-Terri Guillemets

Calendar Tracker

Day 1	Day 2	Day 3	Day 4	Day 5
Day 6	Day 7	Day 8	Day 9	Day 10
Day 11	Day 12	Day 13	Day 14	Day 15
Day 16	Day 17	Day 18	Day 19	Day 20
Day 21	Day 22	Day 23	Day 24	Day 25
Day 26	Day 27	Day 28	Day 29	Day 30

A while back my husband and I bought FitBits for ourselves. I was not happy when I saw how little I was moving every day. Going from being in the best shape of my life to working at home and sometimes...not leaving my desk has meant some less than favorable fitness results but there's always a way to adjust and make a change!

Counting your steps each day can help you build awareness around your movement, daily activity levels, and how often you might be sitting at a desk. For me, I really need to make an effort to get those 10,000 steps in now that I'm at home most days. When I was walking into work in the city each day I would easily get in 4 miles on my daily commute and anything else was a bonus. How much we move each day drastically affects our health and energy levels. Ever notice that on days when you stay on the couch you're more likely to feel cold, sleepy, and less energetic? Walking can have a profound effect on all of those things. It always sounds counterintuitive when I tell myself to get moving for more energy but I know it's true.

Walking 10,000 steps each day can also make you feel mega accomplished. There's something about the number 10,000 that feels like a gold level rockstar, maybe it's just me. Walking more will also make you want to move more. The more I make an effort to stay consistent with my step goals, the more activities I end up doing like yoga, going on a run, trying out a new workout video, or even going on a hike.

One thing to be aware of when you track anything in your daily life is to watch out for perfectionism and obsessive type behaviors. Something that's happened to me and others I know counting calories if I'm not mindful. If you get 9,999 steps, that's still amazing. If you don't reach 10,000 every day but get in 6,000 that's still way more than you were getting sitting on your cute tush. Focus on the progress, not the perfection.

" Don't spend time beating on a wall, hoping to transform it into a door. "

-Coco Chanel

Calendar Tracker

Day 1	Day 2	Day 3	Day 4	Day 5
Day 6	Day 7	Day 8	Day 9	Day 10
Day 11	Day 12	Day 13	Day 14	Day 15
Day 16	Day 17	Day 18	Day 19	Day 20
Day 21	Day 22	Day 23	Day 24	Day 25
Day 26	Day 27	Day 28	Day 29	Day 30

Focusing on our breathing brings us back to our awareness, to our whole self, to the moment we're in, and allows us to de-stress almost instantly. The sad truth is that we often forget to come back to our breath. We're breathing all day, every day and we don't always take time to notice it. Challenging yourself to focus on 10 deep belly breaths each day in the morning and at night can help you start and end your day with ease, focus, and relaxation.

A word on how to get the most out of breathing exercises. Many times we breath in through our chest and feel the energy within our throat, especially as we exhale. I challenge you to focus on your stomach as you breathe, letting the air flow deeply into your whole body, taking a moment to pause after you breathe in and then slowly exhaling back out from your belly, through your chest and lungs, up along your throat, and back out through your mouth.

Breathing deeply this way helps you better activate your PNS or parasympathetic nervous system, the portion of your autonomous nervous system responsible for "rest and digest." It's what calms us down, allows us to relax before sleep, and helps create homeostasis within the body, in other words balancing us out after a stressful situation.

Taking longer to exhale than the time you take to inhale will also improve this process. There's a specific breathing exercise I always share with my clients that can work wonders when you are feeling anxious, overwhelmed, stressed, or just need a moment to seriously chill out. It's simple, easy, and can be done anytime, anywhere, even discretely if you wish.

The 4-7-8 Breathing Exercise

- Start by breathing in for 4 seconds
- Hold your breath for 7 seconds
- Then slowly exhale for 8 seconds
- Repeat this at least three times and notice how you feel in your mind and body

This is a great 30-day challenge to tack on to your nightly and morning routines. Place a sticky note that says "10 deep breaths" by your nightstand or on your bathroom mirror to remind yourself to do them each day. You may find that doing them throughout the day is helpful as well. There isn't anything wrong with doing more breathing exercises if they help you feel grounded and relaxed.

Calendar Tracker

Day 1	Day 2	Day 3	Day 4	Day 5
Day 6	Day 7	Day 8	Day 9	Day 10
Day 11	Day 12	Day 13	Day 14	Day 15
Day 16	Day 17	Day 18	Day 19	Day 20
Day 21	Day 22	Day 23	Day 24	Day 25
Day 26	Day 27	Day 28	Day 29	Day 30

Challenge 64

Bake Something
(Bring the Leftovers to Work or Give to Someone in Need)

Growing up one of my favorite things to do was bake goodies; cookies, biscuits, anything I could make with a box of Jiffy Mix, waffles (okay you don't really bake those but you get it). I also loved eating what I baked but I found that it was a really relaxing and enjoyable experience. Not only did I love the process of baking things but more than anything I loved sharing it with those around me and seeing their expressions as they took the first bite. It was a lot like that scene in *The Wedding Singer* when Rose pays for her music lesson in meatballs and wants to watch him eat them.

I begged (and I mean non-stop) my parents to buy me an Easy Bake Oven. I wanted one more than anything in the world. And one year I finally got one and it was everything to me. I look back now and see why my parents were so resistant to the idea, not because they didn't want me to have fun but because the thing wasn't exactly inexpensive and it made the smallest size of cake I've ever seen in my life. Imagine me at 8 years old, trying to slice a 3" chocolate cake so everyone could have a "slice"—those were the days.

The thing about baking is that it usually involves a lot of love. There's emotion behind food we make and sharing it with others is a way to show it. If you haven't heard of The 5 Love Languages or don't know what yours is, I highly recommend taking the test online. It lets you know how you both give and receive love in all sorts of relationships.

For 30 days your challenge is to bake something. Maybe it won't be every single day but there will be a lot of muffins happening. Try new recipes, experiment with trying to bake things at home with what you have, use alternatives such as applesauce or a flax egg (1 TBSP hot water & 3 TBSP flax meal) instead of eggs, try making muffins with leftover juice pulp, or see what else you can bake in the oven.

Bake things for yourself and your family and then extend that outward. Bake muffins or cookies to bring into work, to donate to a bake sale, or to hand out at an event. Create lunches or baked goods you can hand out to shelters. Get creative with ways that this challenge can help you feel creative and allow you to give back.

"You must be the change you wish to see in the world."

-Gandhi

Calendar Tracker

Day 1	Day 2	Day 3	Day 4	Day 5
Day 6	Day 7	Day 8	Day 9	Day 10
Day 11	Day 12	Day 13	Day 14	Day 15
Day 16	Day 17	Day 18	Day 19	Day 20
Day 21	Day 22	Day 23	Day 24	Day 25
Day 26	Day 27	Day 28	Day 29	Day 30

I have this crazy feeling that you're not giving yourself enough credit for all the things you do in life. You're hard on yourself, you assume everyone else does just as much, you think what you do doesn't deserve credit from yourself or others because it's "just xyz." Well luckily I'm here to call bullshit and tell you that what you do each day does in fact deserve praise.

We have a tendency to be pretty hard on ourselves or feel guilty for being proud as if it's selfish, snobby, or self-centered. In a lot of ways these thoughts and patterns are deeply ingrained and it can be hard to shake them. There's no reason you shouldn't take time to acknowledge yourself and what you do each day. Doing so leads you to cultivate more gratitude within yourself and for others. The more I take time to regularly write down what I'm accomplishing and making effort on each day, the more I find myself thanking my husband for small things as well. It opens up a beacon of appreciation that we can't help but spread outwardly.

Sometimes there are days when getting out of bed is an accomplishment, believe me, I've been there. And other days you may slay a huge accomplishment, doing something you never would have thought possible before. It's important to sit with all of these and not try to undervalue the small things. Everything we do builds and compounds over time, leading to new thoughts, new habits, and ultimately new realities.

For the next 30 days, I want you to create a space in a journal, on your computer, or on a whiteboard on your fridge, and write down one thing you did each day that made you feel proud of yourself. I don't care if it feels stupid, or small, or irrelevant, write it down.
Ideas to get you started:

- Saying "no" to someone
- Making the bed first thing in the morning
- Prepping meals for the week
- Not swearing during your commute to work
- Taking a deep breath instead of yelling

" Tough times never last, but tough people do. "
-Dr. Robert Schuller

Calendar Tracker

Day 1	Day 2	Day 3	Day 4	Day 5
Day 6	Day 7	Day 8	Day 9	Day 10
Day 11	Day 12	Day 13	Day 14	Day 15
Day 16	Day 17	Day 18	Day 19	Day 20
Day 21	Day 22	Day 23	Day 24	Day 25
Day 26	Day 27	Day 28	Day 29	Day 30

Challenge 66

This challenge is a lot like the last one in #65 but hold on because it's still different and worth your time. Instead of focusing on one thing that made you proud, this challenge is about making a list of everything you accomplished each day. I'm talking about all the little things you do throughout your day whether you work a 9-5, stay at home, or are in school. Whatever it is you may be doing, there's a good chance you're undervaluing what you accomplish each day.

I started this practice way back during my undergrad when I was a Freshman and only 18 years old. Good lord I was so young. I noticed that it was really easy to get down on myself for not working "hard enough" in school. There were big chunks of time where I didn't have the validation of a good grade or the hand holding of a teacher to tell me I was amazing. Because in college, there's no time for that, you're an adult and that English 101 class has 268 other students in it. Get ready to build your own self-worth, kiddo. This was my sort of pep talk I had with myself.

I had a solid routine, I'd finish all my 100 level courses by noon every day, grab lunch at the cafeteria, often write my grandmother a letter (how cute is that?!), and then head to the library. I'd spend about four solid hours there getting all my reading done and working on homework, papers, and math assignments. By the time I got back to my dorm I was burnt out and restless. Then one day I decided to keep a running list of what I did each day. I started writing down how many math problems I solved, how many pages of each textbooks I read, how many times I walked up the giant hill to my dorm on campus, how many vegetables I ate at lunch, etc. What began to happen at the end of each day as I trekked up the giant hill to my dorm in Kappa (I had the highest dorm room on campus) was that I started to get this crazy rush of endorphins. Because I had written down everything I did, I would run through that list in my head as I walked back home. And instead of every day feeling exhausting, I'd feel on fire, like I was ruling my life, and I couldn't wait to get up each morning.

I'm now encouraging you to do the same thing. Keep a place to write down what you're doing each day, how many emails you delete, how many meetings you went to, a rough phone call you handled with grace, whatever it is. These lists will also be a source of empowerment to come back to later.

"If the plan doesn't work,
change the plan, but never the goal."

-Unknown

Calendar Tracker

Day 1	Day 2	Day 3	Day 4	Day 5
Day 6	Day 7	Day 8	Day 9	Day 10
Day 11	Day 12	Day 13	Day 14	Day 15
Day 16	Day 17	Day 18	Day 19	Day 20
Day 21	Day 22	Day 23	Day 24	Day 25
Day 26	Day 27	Day 28	Day 29	Day 30

What is a bullet journal you ask? Bullet journaling is a style of journaling created by Ryder Carroll that incorporates rapid logging, bullet points, and symbols to easily add, reference, and refer to information quickly and efficiently. The trend has gone viral over the years and you can find countless Facebook Groups devoted to the practice as well as blogs explicitly focused on bullet journal styles and strategies. Pro users refer to bullet journaling as their "bujo"—making sure you know the lingo here!

I've personally been journaling my entire life but didn't get back into daily journaling and establish my own style of journal practice until about five years ago. I take a variety of "journaling styles" and create my own ideal way of keeping my journal. You can take my journaling mini course and learn all my tips by visiting **SarahRoseCoaching.com/courses**

Starting a bullet journal can be beneficial in many ways. For example, if you're a rapid (and perhaps excessive) note taker, you may find yourself with a sea of sticky notes and papers on your desk. I always made excuses for myself saying things like *"I work better in a mess!"* or *"A chaotic desk means a full mind!"* But honestly, I always felt like I was forgetting something, and usually was.

Having a bullet journal allows you to take all of your notes in one place that won't blow away when the air vents come on at work. It also gives you a structured system and approach to finding to-do lists, making sure they get completed, and mitigating any tasks that need to be dropped or re-scheduled to a later time.

What you use your journal for or how you use it is ultimately up to you but keeping a daily journal can help you be more productive, feel less stressed, and create any outlets you need for venting or releasing thoughts or feelings that don't serve you. I am a huge data and trend nerd so I love to create habit trackers and logs of my progress on various things.

Grab your free printable habit tracker with 101 ideas to improve your daily life by visiting the blog at **SarahRoseCoaching.com/blog**

" It wasn't raining when Noah built the ark. "

-Howard Ruff

Calendar Tracker

Day 1	Day 2	Day 3	Day 4	Day 5
Day 6	Day 7	Day 8	Day 9	Day 10
Day 11	Day 12	Day 13	Day 14	Day 15
Day 16	Day 17	Day 18	Day 19	Day 20
Day 21	Day 22	Day 23	Day 24	Day 25
Day 26	Day 27	Day 28	Day 29	Day 30

Challenge 68

Keep Track of Your Expenses

*W*hen I was 16 I got my very first job working at a dry cleaners after school and to this day it was one of my favorite jobs. Not because of the dry cleaning fumes or angry customers but because of how often I found myself laughing uncontrollably, how grown up it made me feel, and how many times it allowed me to get breadsticks next door. I had my first checkbook (back before everyone had a debit card) and every time I went next door I'd write them a check for $3.45 for breadsticks, an afterschool special I'm pretty sure they made just for the girls at the dry cleaners. I was weirdly responsible as a teenager. I was very mindful of spending and saved about 90% of any money I made. But there was one day as I looked through my checkbook log that I was in shock of how much I'd been spending on breadsticks alone! It was close to $100 over a couple months and if you're already doing the math, that's a LOT of after school breadsticks.

Seeing that number made me change my ways (and start bringing an apple to work each day). The biggest lesson it taught me though was that what we track gets measured and what gets measured gets improved. Where we bring awareness is where we facilitate growth and change.

Tracking your expenses for 30 days can do just that. It will allow you to not only see how much money is coming in but where exactly it's going. This gives you the opportunity to explore the "why" behind your spending, any impulsive spending habits, and gives you more freedom and control over your finances because you can then make decisions when you have the awareness.

If you're already monitoring your spending, kudos, but there may be a few more tips I have for you below that you can implement into your daily systems. If you're the type of person who doesn't worry about it until it becomes an issue, imagine how much you can empower yourself by creating awareness so when financial circumstances do change you're prepared.

For 30 days, I challenge you to keep a list of where you are spending your money and what you are spending it on. Watching this list grow over the 30 days will give you a huge gift of awareness for your spending habits!

◑ Tips for tracking your spending:
- *Be mindful of where your money is going. Consider using a cash system if seeing the money leave your hands helps.*
- *Set a plan for grocery shopping trips and don't shop hungry!*
- *Make a list of your bills and their due dates and a schedule for when you will pay them.*
- *Set aside "fun money" or money just for yourself, giving yourself permission to save and buy things that bring you joy*

Calendar Tracker

Day 1	Day 2	Day 3	Day 4	Day 5
Day 6	Day 7	Day 8	Day 9	Day 10
Day 11	Day 12	Day 13	Day 14	Day 15
Day 16	Day 17	Day 18	Day 19	Day 20
Day 21	Day 22	Day 23	Day 24	Day 25
Day 26	Day 27	Day 28	Day 29	Day 30

*B*ack in challenge #2 I encouraged you to spend 5-10 minutes a day meditating. For the next 30 days I encourage you to listen to a guided relaxation or even relaxing music each day. Guided relaxation is a little bit different than meditation in that it can be a great first step without the added pressure of meditating any one way. How you feel relaxed and what relaxes you is unique to you and finding music that calms you down can help you create a toolbox of self-care strategies and resources for you to come back to again and again.

Relaxation music can be found on YouTube, various websites, and even in phone apps like Focus Zen and Relax Melodies. What's great about relaxation music is that you don't have to be completely focused or in a meditative state to enjoy or benefit from it. I often use relaxation music while I'm working or writing to help me focus and inspire me with creative ideas.

This brings me back to when I was around 12 or 13 and I got my first Enya CD. I was immediately entranced by her voice and the smooth, calming melodies of her songs. I used to put her CD in my boombox and hit the repeat button (oh the 90s) and lay in my bed listening to it for hours just thinking about life. It wasn't until years later that I read an article about how her voice and her songs had been scientifically proven to reduce your heart rate and blood pressure just be listening to them! Since then I have always been fascinated by the healing qualities of music and sound.

As a baby my Mom would always turn on special music when she woke me up in the morning. I remember watching a home video of her going in, turning it on, and waking me up as I rolled over in my huge diaper. I don't remember it as a baby but I can see why she did it. Seriously, how adorable is my Mom?!

Listening to relaxing music can be something you put on in the morning as part of your own routine, it can be something you turn on while cleaning or when the house is getting a little chaotic depending on how many animals, roommates, or kids you may have running around.

Add relaxation music to your day for 30 days and see how it impacts your life.

" *The grass is greener where you water it.* "

-Neil Barringham

Calendar Tracker

Day 1	Day 2	Day 3	Day 4	Day 5
Day 6	Day 7	Day 8	Day 9	Day 10
Day 11	Day 12	Day 13	Day 14	Day 15
Day 16	Day 17	Day 18	Day 19	Day 20
Day 21	Day 22	Day 23	Day 24	Day 25
Day 26	Day 27	Day 28	Day 29	Day 30

Challenge 70

*C*hances are you've been driving the same route back home for a while now whether it's your commute or a particular way you get to a friend's house. When was the last time you got lost? And I mean more than losing your car in one of those multilevel parking garages—those things are the worst! There was a time years back when I took myself to Green Lake down in Seattle and on my way back to my 400 square foot studio in Northgate, I got incredibly lost. It took me 2 hours to find my way back home maybe 10 miles away. Yes, I'm a little more directionally challenged than some but it was an interesting experience. Without a charged phone or a GPS of any kind, I had to rely on my instinct (which again, needs some practice) and notice everything around me. By the time I did make it back home I had a much better sense of Seattle neighborhoods and which streets were one-way and so forth. I'm not telling you to go out there and get yourself frustrated and lost like I did, but consider what you learn when you have to navigate something on your own.

You may wish to spread this challenge out or intertwine it with something else. Driving somewhere new or different each day can give some variety to your thoughts and your routines that often go unnoticed by the subconscious mind. It reminds me of how many times I've found myself on autopilot driving to a particular destination only to realize my intention was to drive an entirely different direction. Every time I move somewhere new (which has been around 13 times in the past 10 years), I take some time to get lost on the backroads. I drive past my exit and see what's beyond my normal route. I look up parks and drive to them as if they have a treasure there waiting for me. Each and every time I ventured somewhere new, I found how roads connected to my regular route, different ways to go if there was traffic, or new coffee shops and fun stores I never would have found otherwise. Ultimately, driving somewhere new each day even if it's only 5 minutes further down the road allows you to see how everything is connected.

Challenges for you:

- Drive 5 minutes past your new location and see where you end up
- Turn left instead of right on your way out on a Saturday
- Look up local parks you haven't been to
- Try a new coffee shop or restaurant
- See what you find on a detour

" To travel is to live. "

-Hans Christian Andersen

)))●● Calendar Tracker ●●((

Day 1	Day 2	Day 3	Day 4	Day 5
Day 6	Day 7	Day 8	Day 9	Day 10
Day 11	Day 12	Day 13	Day 14	Day 15
Day 16	Day 17	Day 18	Day 19	Day 20
Day 21	Day 22	Day 23	Day 24	Day 25
Day 26	Day 27	Day 28	Day 29	Day 30

Challenge 71

This challenge plays off challenge #70 but in a couple different ways. Instead of driving somewhere new, I'm challenging you to try new things and step inside new places. There have been numerous times when I've lived in a town for a year or more and people will ask, "Have you been to_____ yet?" When my response is that I haven't, I'm usually met with statements like why not?! It's a fair question and the answer is that usually I get set in my ways, my new routine, and don't think to venture out of it or try much else. I had the same kind of mindset when I was a kid. Take me to a new restaurant and I'd struggle to make a decision but if I found a menu item I liked, I'd order that always for the rest of time, infinity. Not that there's anything wrong with knowing what you like and choosing that consistently, but it did put a damper on broadening my horizons in a few ways.

To start off this challenge, make a list of all of the local places you've been meaning to go to or have heard about that you'd like to try. Maybe there's a small walkway of local stops you've yet to spend the day at, a seasonal flea market, antique stores, farmers' markets, thrift stores, or even a new grocery store that you haven't been to yet.

1. _____

2. _____

3. _____

4. _____

5. _____

6. _____

Once you've made your list, get clear on what it means for you to visit each place. Stay open minded and give yourself permission to go with the flow. For example, if you have a new coffee shop on your list and you get there to only find that it's uncomfortable and unappealing, then leave. You can still say that you've been there. Part of this challenge is to get yourself out of your comfort zone while helping you learn more about what you like and don't like. This is something that can change drastically over time, or in my case, about every 7 years or so. Trying new places and going to local venues you haven't explored before can help you get in touch with different aspects of your personality and being that you a) may not have explored before or b) may have forgotten about.

Be a tourist in your own neighborhood. Let the adventure begin!

"If it scares you, it might be a good thing to try."

-Seth Godin

Calendar Tracker

Day 1	Day 2	Day 3	Day 4	Day 5
Day 6	Day 7	Day 8	Day 9	Day 10
Day 11	Day 12	Day 13	Day 14	Day 15
Day 16	Day 17	Day 18	Day 19	Day 20
Day 21	Day 22	Day 23	Day 24	Day 25
Day 26	Day 27	Day 28	Day 29	Day 30

Challenge 72

Go to a Park

*W*hen I look back on times in my life that I've felt the happiest and the most simple forms of joy, I find one common denominator; I was spending time outside on the regular. Even ten minutes outdoors can do wonders for your mood, immune system, and mental health as we've discussed in other challenges so far. Going to a park each day encourages you to be active, take time for yourself, and be in the moment with the environment around you. It's a simple routine shift that can fuel you in ways you may not have considered before.

Every now and again during the weekend, there are moments when I look at my husband and we both express how the mood of the room feels off. There's a weird energy and we both feel moody, anxious, or frustrated and we can't put our finger on it. It's a lot like that cabin fever feeling you get after a big storm or during the cold winter months when you don't leave the house as often. When these moments arise, we get up, get in the car to go to a park, or head out on a walk to clear our minds. Granted, we don't always want to, Netflix has a powerful pull, but we always feel better afterwards.

Challenging yourself to visit a park each day allows you to breathe in fresh air, to take a moment to look inward for anything you are seeking, instead of distracting yourself without external forms of entertainment. Few people take time to be with their thoughts, their breath, and their bodies on this level. It can be uncomfortable at first, maybe even feel a little awkward, but I challenge you to stick with it. Learn more about the inner workings of your mind and how your body feels as you experience different thoughts and emotions. Creating this mind/body connection will serve you powerfully over time.

Some things to do at the park:

- Bring a yoga mat or blanket to sit on, stretch, or meditate
- Bring a bottle of water and get in 32oz while you're there
- Bring a basketball or soccer ball
- Bike to your local park
- Skip rocks
- People watch
- Bird watch
- Take time to notice the smell of the air, the temperature of the breeze, and how nature around you moves and flows

150

Calendar Tracker

Day 1	Day 2	Day 3	Day 4	Day 5
Day 6	Day 7	Day 8	Day 9	Day 10
Day 11	Day 12	Day 13	Day 14	Day 15
Day 16	Day 17	Day 18	Day 19	Day 20
Day 21	Day 22	Day 23	Day 24	Day 25
Day 26	Day 27	Day 28	Day 29	Day 30

Libraries are magical places that I think are totally underrated. Where else can you go to find limitless information, ideas, stories, knowledge, wisdom, and resources to help you bring it all together? I'm a regular library-goer. I love the smell of the books, the rustling noises of the patrons, the regular visitors that have their one spot where they read, the busy bloggers who bring their laptops and headphones, the kids who stand in complete awe of all the books before them. It's a true place of solitude and abundance and no matter where you go, you can find one.

Libraries are more than just books on shelves, they are community centers for activities, mental expansion, growth, and support. Many local libraries host coloring book nights, events and support groups for youth, tutorials and workshops for coding, legal rights, and even sewing. There have been countless times when I've walked into my local library to find donation bins or items collected that are free to take such as used baby clothes, books, and more. When the world feels cold, overwhelming, and lacking in compassion, I bring myself back to the library and I'm reminded of how much those things exist in abundant forms.

Going to the library can also be a cleansing experience, a way to allow yourself to focus, find clarity, or get outside of your regular routine. I find that when I go to the library to write or work on a project, I am worlds more productive than anywhere else. Sometimes I go with my laptop to work on a specific project and other times I simply bring a journal and a pen and freewrite or sit with my thoughts and doodle or mind map. I always leave with new insights, a sense of calm, and the euphoria of accomplishment, no matter what I decided to do.

There are other times when I may feel bored or overwhelmed and I go to stroll through the aisles, I choose a random book that I feel called to, read the back, and sometimes check something out that I would have otherwise never considered. I'm guilty of checking out way too many books at once but also cannot get over the sound and smell of a library book in my hands. The way it slowly crinkles as I open its cover, considering how many minds drifted through the same pages, how many miracles or changes began with just one page. Discover yourself and so much more as you visit the library. Go to the same one or branch out and try new ones. You can even checkout Little Libraries around your community that others have put up. Just make sure you leave a book if you take one.

Visit littlefreelibrary.org to find ones near you!

"Avoiding failure is to avoid progress."

-Unknown

Calendar Tracker

Day 1	Day 2	Day 3	Day 4	Day 5
Day 6	Day 7	Day 8	Day 9	Day 10
Day 11	Day 12	Day 13	Day 14	Day 15
Day 16	Day 17	Day 18	Day 19	Day 20
Day 21	Day 22	Day 23	Day 24	Day 25
Day 26	Day 27	Day 28	Day 29	Day 30

Challenge 74

*I*n challenge #9 I encouraged you to make time to watch your favorite TV show for 30 days. Whether you've done that yet or not, I hope it gave you some perspective on how self-care takes many forms and it isn't so much about doing the exact same things every day but about creating variation, change, and flow to your overall self-care routine and practice.

For this challenge, I'm asking you to go 30 full days without watching TV. Now, you must decide what that means to you and if it will include internet videos or clips or not. Personally, when I choose to unplug from TV, I like to unplug from all sorts of media, but do what feels best, and most realistic to you.

In 2015, the Bureau of Labor Statistic reported that the average American spends about 2.8 hours a day watching TV. For the sake of ease, let's say that you spend about 2 hours a day watching TV, internet videos, etc. During the workweek alone, that's 10 hours of your time. Imagine what you could do with two extra hours in your day. And for a second, consider what you might be avoiding when you do watch TV. For some, that's an uncomfortable question. You may be thinking, I'm not avoiding, anything, Sarah! We often fall into the comfort of our routines and routines often involve zoning out and not thinking about things that are bothering us. This time is important, of course, but when it becomes a habit over time, we stop taking stock in what we made need to shift or change to feel happy within our daily lives.

By taking 30 days to give up TV, you aren't really giving up much, instead you're gifting yourself extra time, whether that's 30 minutes or 3 hours. It may feel overwhelming at first, you may start to realize how much TV was your "go-to" solution when you felt bored, tired, or needed to relax after work.

Before you begin this challenge, take a few moments to make a list of things you'd like to do with your newfound time. It may be reading a book every evening, spending time with family, writing or journaling, meditating, baking or cooking, or starting a hobby you've always wanted to dive into.

◑ Tips for making this challenge easier:
- *Consider how your living room or space is arranged around the TV. Many times we have entire rooms set up in ways that make TV the first thing we think about doing, or the easiest thing to do after we sit down. Consider re-arranging furniture so couches and chairs face each other or the window instead of the TV.*
- *Put any laptops, iPads, or other devices out of sight that encourage online streaming or other TV-like activities*

Calendar Tracker

Day 1	Day 2	Day 3	Day 4	Day 5
Day 6	Day 7	Day 8	Day 9	Day 10
Day 11	Day 12	Day 13	Day 14	Day 15
Day 16	Day 17	Day 18	Day 19	Day 20
Day 21	Day 22	Day 23	Day 24	Day 25
Day 26	Day 27	Day 28	Day 29	Day 30

Challenge 75

*W*hen I first started living with my husband one of the biggest things I noticed was how many diet soda cans infiltrated our living room and recycling bin. They felt endless and they accompanied him with many meals. I wasn't coming from a place of judgement as I made this observation but instead, was wondering what would happen to his health after another decade of drinking these chemical storms. Whether you enjoy diet soda or a regular carbonated beverage on the regular, you're most likely aware that they aren't ideal for your health short or long-term. When I was younger I'd rarely read nutrition facts or labels and when I did I'd think *"Oh a Coke is only 150 calories, I can handle that"* and go on my merry way.

The problem is that a single Coke has 39g of sugar and other beverages can have even more. If you ingested that much sugar in regular form you'd most likely throw up but because of the carbonation and structure of a soda, your stomach "accepts" it a little more readily. Every time we drink a sugary beverage like a soda, our body instantly stores it as fat. There is literally no nutritional value in a soda and while it may give you a burst in energy, the sugar crash afterwards will have your pancreas pumping out insulin trying to bring your blood sugar back to a normal level. It's why you may feel even more tired after having something sugary, yet at the same time, crave even more.

Diet soda isn't much better. Sure it's calorie free but the ingredients in it such as *aspartame*, formerly known as NutraSweet, and now being called *aminosweet* can wreak havoc on your body and have been shown to be a carcinogen. Whether or not you feel concerned about this, consider what drinking a product like this on the regular could do to your body overtime.

One way to switch soda out of your life is to replace it with seltzer water. The carbonation is still there with a slight flavor without the added sugar and negative health effects. Stocking your fridge with seltzer water can be a great way to switch from soda to a healthier option.

*" What lies behind us and what lies before us
are tiny matters compared to what lies within us. "*

-Henry S. Haskins

Calendar Tracker

Day 1	Day 2	Day 3	Day 4	Day 5
Day 6	Day 7	Day 8	Day 9	Day 10
Day 11	Day 12	Day 13	Day 14	Day 15
Day 16	Day 17	Day 18	Day 19	Day 20
Day 21	Day 22	Day 23	Day 24	Day 25
Day 26	Day 27	Day 28	Day 29	Day 30

*I*f you feel the constant urge to always be on the go, you're not alone. Everything feels instant these days and if it's not, we often get frustrated. Never before have we been able to acquire things so quickly; information, food, communication, etc. The problem is that it sets the pace for our everyday lives. If decisions can be instant then we should be making them faster. If meals can be easily purchased at the drive through, then we should do whatever we can to save time. Society is catching up and more and more people are realizing that faster, isn't always better.

It's why for 30 days I'm challenging you to make time to embrace the slow, to put down the phone, take a deep breath, and do absolutely nothing. This was a struggle for me at first. I was surprised how much guilt came up when I slowed down. I kept thinking about how productive I could be if I just kept going or what I might miss out on if I didn't stay on top of the never-ending wave of information.

The truth is that never slowing down leads to burnout and burnout can be hard to come back from. I've had my own experiences with this that left me in a depression, little energy, and a complete lack of motivation or desire to even start again. Taking time to slow down rewards you in huge ways but they aren't as instant as our normal ways of valuing productivity.

When you take time to sit still, be with your thoughts, and breathe, you are doing a number of things. You are taking time to activate your parasympathetic nervous system, responsible for "rest and digest" that allows you to calm down and keeps you from building up the stress hormone, cortisol.

Doing nothing even for five minutes allows you to check in with yourself, your mind, your body, and ask what you need, how you're feeling, and if anything needs to shift or change. I often ask these simple questions with my coaching clients after we've spent some time diving deep into a subject on the phone. We take a minute to check in and I ask if they are still interested in moving forward with the specific topic. It's amazing how often people say, *"Oh wow, I'm not sure, I hadn't even considered that I had a choice."*

Think about that for a moment. You have a choice in every moment of your life to pause, to breathe, to go in a new direction, to stay longer with a thought or idea, or to scrap something altogether. Taking time to do nothing and be with your mind will allow you to bring clarity, certainty, and alignment to your decisions.

Calendar Tracker

Day 1	Day 2	Day 3	Day 4	Day 5
Day 6	Day 7	Day 8	Day 9	Day 10
Day 11	Day 12	Day 13	Day 14	Day 15
Day 16	Day 17	Day 18	Day 19	Day 20
Day 21	Day 22	Day 23	Day 24	Day 25
Day 26	Day 27	Day 28	Day 29	Day 30

Did you know that your body has a sleep cycle or circadian rhythm that helps regulate when you feel tired and wake up? It's one of the reasons daylight saving time can throw us for a loop and why you may feel extra tired or have a hard time feeling regulated or grounded when you have too much light or dark during the day. The 24 hour cycle that we go through each day helps regulate melatonin secretion as well as when it starts and ends. Melatonin is a hormone found within our bodies that is released in the evening to help us relax and sleep and stops being released in the morning to help us wake and start the day.

One interesting thing about melatonin is that it decreases in adults as we age and in teenagers it's actually released later in the evening which can lead to later bedtimes and the urge to sleep in. So I wasn't as lazy as I used to think!

Melatonin production increases when it's dark and decreases when it's light. It's one of the main reasons why artificial lights and electronic devices can make it difficult to fall asleep. Your challenge for the next 30 days to help with your circadian rhythm and melatonin production is to turn off all electronics two hours before bed. I've been guilty many times of laying in bed with my phone in my face scrolling endlessly through the interwebs. It always results in a terrible time of trying to fall asleep. My body feels restless and my mind goes crazy. It makes it much more difficult to meditate and even do breathing exercises that normally help calm me down.

Putting your phone, laptop, or any tablets away two hours before bed can help prepare you for sleep and engage in activities that will serve a good night sleep. Bonus points if you turn off the TV, dim the lights in your home, or even light candles. All of these things can boost your melatonin production and help you fall asleep faster and experience a deeper sleep throughout the night.

Staying consistent with your bedtime and nightly routine will also help you feel more rested, mentally aware, and less emotionally fatigued.

" The best way to predict the future is to invent it. "

-Alan Kay

Calendar Tracker

Day 1	Day 2	Day 3	Day 4	Day 5
Day 6	Day 7	Day 8	Day 9	Day 10
Day 11	Day 12	Day 13	Day 14	Day 15
Day 16	Day 17	Day 18	Day 19	Day 20
Day 21	Day 22	Day 23	Day 24	Day 25
Day 26	Day 27	Day 28	Day 29	Day 30

O ne thing that's changed my life is realizing how much my thoughts impact my daily life. The types of thoughts we have and the way we think about them contribute to our mindset, defined as *"the established set of attitudes held by someone."* It's similar to the self-fulfilling prophecy in that what we believe often ends up being how we act resulting in what we originally assumed to be true.

When I say "negative thoughts" I'm talking about thoughts that don't serve you, thoughts that may limit you, fuel self-doubt, or make you feel less than. It's important to note that while some thoughts and feelings can feel negative and not lead to the best of decisions or thoughts about ourselves, I'm hesitant to call any one thought "bad" over another. This is because we're human beings and it's completely normal for the mind to have a mirage of thoughts, experiences, and responses. So even though for the sake of this exercise we'll be focusing on negative thought patterns, I challenge you to come at them with curiosity over judgement, looking to understand them instead of push them away or feel ashamed of them.

For the next 30 days during this challenge, your task is to write down 2-3 negative thoughts you have and then flip each one with 5 positive alternatives. This is the 5:1 ratio of thoughts and has been shown to help rewire our brains and thought patterns over time. Each time you have a negative thought that stalls you, neurons fire within your brain following similar thought patterns. It's why having one frustrating thing happen in the morning can make it feel like the entire rest of the day sucks.

Think of the synapses and neurons firing in your brain as a determined kid with a sled on a snow day. That first attempt at going down the hill may take some wiggling and maneuvering. She's got to create the sled path and work her way through the snow. Yet with each recurrent sled down that same path, it becomes iced over, compacted, and easier for the sled to follow. Soon she merely has to sit at the top of her snow path and it will wind her down the hill in its tracks.

Our brains work in similar ways. We have a thought or situation happen to us in the past, form a neural pathway of thoughts, reactions, and responses, and over time it becomes an automatic response. Writing down 5 positive thoughts for every negative thought you have helps you retrain your brain and create new neural networks of automatic behavior. You can actually change the way you automatically feel or respond to certain stimuli.

> ◑ Here's an example of how you can carry out this exercise:
> **Negative thought:**
> • *I always fail at this, I suck, maybe it's time I finally give up*
> **Positive counter thought:**
> • *It takes a while for new habits to form, I'm going to be easier on myself*

Calendar Tracker

Day 1	Day 2	Day 3	Day 4	Day 5
Day 6	Day 7	Day 8	Day 9	Day 10
Day 11	Day 12	Day 13	Day 14	Day 15
Day 16	Day 17	Day 18	Day 19	Day 20
Day 21	Day 22	Day 23	Day 24	Day 25
Day 26	Day 27	Day 28	Day 29	Day 30

A couple of challenges back in #77, I walked you through the importance of ditching electronics before bed if you don't want to mess with your melatonin levels. This challenge focuses in a different way having you pick a solid (and specific) bedtime to commit to. If you're already rolling your eyes and pulling yourself away from this idea, you're not alone. I fight myself on bedtimes often, it's the toddler in me wanting to rebel. But I'm an adult and I know that when I don't get enough sleep or have a regular sleep routine I get groggy, moody, and I pick fights with my husband at 5a.m. because he can't read my mind (love you, Kyle!).

No matter how many times you want to prove to yourself that you can totally make up all that lost sleep on the weekend, your morning self isn't going to buy it when you're trying to run on five hours of sleep and three extra cups of coffee. Growing up my Mom always told me to consider my "morning self" when my "night self" wanted to stay up watching Season 1 of The Real World. She pointed out how much we ignore our future needs when it feels like our current self is getting away with something. This always stuck with me. Poor morning self, you deserve better!

When I work with clients on establishing nighttime routines, they hate hearing the word "bedtime." I think most people hate that word. Call it whatever you want but choose a time you can realistically stick to. Consider how many hours of sleep you really need to get to feel like your prime self and work backwards. Give yourself a buffer as well or a window of time to prepare for sleep. I always tend to spend an extra 20 minutes running around at night setting the coffee, brushing my teeth, and putting things away. Schedule that in as well. If your goal is to be asleep by 10, consider what time you need to be in bed before that to make that a reality.

" Failure is the condiment that gives success its flavor. "

-Truman Capote

Calendar Tracker

Day 1	Day 2	Day 3	Day 4	Day 5
Day 6	Day 7	Day 8	Day 9	Day 10
Day 11	Day 12	Day 13	Day 14	Day 15
Day 16	Day 17	Day 18	Day 19	Day 20
Day 21	Day 22	Day 23	Day 24	Day 25
Day 26	Day 27	Day 28	Day 29	Day 30

Challenge 80

This is an exercise I remember doing when I was 14 but stopped doing over time because I don't know...I kind of just assumed that once I got close to 30, I'd love my body automatically and wouldn't need "stupid exercises" to make myself feel better. Truthfully, body image and self-love are a never ending practice and making these kind of rituals and routines a regular occurrence is what can help us to feel our best and not be so damn hard on ourselves.

Taking time each day to focus on what you love about your body can be life changing. I'm not just talking about physical appearance, either. In fact, I challenge you to look for other things before you focus on aesthetics, not because you shouldn't love the way you look or enjoy it, but because focusing on what your body can do can be an empowering place to start. I'll admit that when I do this and stand in front of the mirror I'm not always happy. I find myself starting with how I feel in my body, which isn't always comfortable (giant burritos lead to food babies that make me feel sluggish). But if I be patient with myself and stand there for a little longer, I begin to realize that my body is pretty amazing. It's gotten me to where I am today. It's gained and lost weight, it's built muscle, it's changed shape and grown stronger, it heals when I get cuts and bruises, it alerts me when I'm hungry, sad, or tired, it tells me when I need to rest, it feels amazing things, and it magically warms itself back up with my body heat.

See where I'm going with this? Your body does amazing things every single day that you may not even be acknowledging. Instead, we often beat our bodies up with insults, hurtful statements and thoughts, and tell ourselves we're not good enough because we don't fit a certain mold or expectation. As you stand there with yourself practice making mental notes of things your body has accomplished. Maybe you've ran a mile or a marathon, maybe you've had a baby, overcome an illness, fought off a cold, moved that couch by yourself in college, or somehow ran in heels to catch a bus. Give your body credit for all the amazing things it does and notice how you start to feel even a few days into this 30 day challenge.

" You are imperfect, permanently and inevitably flawed. And you are beautiful. "

-Amy Bloom

166

Calendar Tracker

Day 1	Day 2	Day 3	Day 4	Day 5
Day 6	Day 7	Day 8	Day 9	Day 10
Day 11	Day 12	Day 13	Day 14	Day 15
Day 16	Day 17	Day 18	Day 19	Day 20
Day 21	Day 22	Day 23	Day 24	Day 25
Day 26	Day 27	Day 28	Day 29	Day 30

Challenge 81

Try Daily Dry Brushing

*W*hat is dry brushing you ask? Just another self-care trick I have up my sleeve for you! Now before we get into this I want to let you know that a lot of claims have been made about this. Articles have claimed that dry brushing is the miracle for removing cellulite and can help remove toxins from your body. There is talk and supportive claims on both sides. The reason why I'm challenging you to try daily dry brushing is not because I have evidence that it will purify your body but because I've tried it myself and it's relaxing as f*ck.

Finding ways to relax your body is fantastic, period and as I've mentioned before, can help activate your parasympathetic nervous system. So instead of telling you to go out and buy an $80 dry brush blessed by a spa specialist (which by all means, please do if you want to, I'm not stopping or judging you), I'm here to encourage you to do something that feels good on your body. And hey, who knows, maybe you'll experience some of the benefits along the way, we're all guinea pigs here.

Find a dry brush that feels good on your skin, the idea here is to get in touch with your body and bring touch back to areas of your skin that you may hardly check. This also gives you an opportunity to do daily skin checks and become more aware of your body in general. Dry brushing techniques suggest brushing toward your heart depending on where you start. Use a light pressure and try to go over your entire body. Dry brushing may help your skin become less sensitive. Overall, take stock in the fact that you're trying something new.

Make it a part of your morning or night routine and notice how it makes you feel. Does it calm you down or invigorate you? Do you notice certain areas that are more sensitive than others? Look at this challenge as a way to build awareness with your body.

" Courage is like a muscle. We strengthen it by use. "

-Ruth Gordo

168

Calendar Tracker

Day 1	Day 2	Day 3	Day 4	Day 5
Day 6	Day 7	Day 8	Day 9	Day 10
Day 11	Day 12	Day 13	Day 14	Day 15
Day 16	Day 17	Day 18	Day 19	Day 20
Day 21	Day 22	Day 23	Day 24	Day 25
Day 26	Day 27	Day 28	Day 29	Day 30

*O*ne of my favorite hobbies over the past couple years has been reconnecting with my love of tarot and oracle cards. I had a deck when I was younger that I used to study with determination but then put it all aside as I got older thinking it was too immature. Honestly, I love tarot and oracle cards as a tool for self-reflection and for considering different and varying perspectives when I have something on my mind. I like that they both inspire and challenge me to reevaluate any limiting beliefs or assumptions I may be holding onto. I know not everyone is open to the idea of decks and cards but if you're curious, they can be a fun ritual to bring into your self-care routine.

Ultimately it's how you choose to read and interpret them that will lead to what you get out of the experience. I personally don't view them as holding on special power but instead use them as a reference tool or a sort of totem to reconnect with myself.

There are differences between Tarot and Oracle cards. Tarot decks are structurally different for example in that they typically have around 78 cards per deck that are broken down into major and minor arcana with the minor arcana being broken down into four suits. Tarot cards can also have reverse meanings depending on their upright or reversed positions. Oracle decks are a bit simpler in that they don't have a set standard of cards per deck and are left open for interpretation by what's presented on the card. Some decks that I own have 44 cards, others more or less. Other forms of oracle decks can include affirmation decks or cards and so forth.

How to use them on a daily basis:

For 30 days you can either pull a single card, explore the meaning online or in the provided guidebook and journal about it, or sit quietly in reflection. Other fun ways to use either type of deck involve spreads or pulling multiple cards and placing them in a specific format. For example, a common thread involves pulling three cards, one for past, one for present, and one for the future. You can then decipher the meaning of each card with its placement and make your own assessments as you see fit.

> " *It took me quite a long time to develop a voice, and now that I have it, I am not going to be silent.* "
>
> -Madeleine Albright

Calendar Tracker

Day 1	Day 2	Day 3	Day 4	Day 5
Day 6	Day 7	Day 8	Day 9	Day 10
Day 11	Day 12	Day 13	Day 14	Day 15
Day 16	Day 17	Day 18	Day 19	Day 20
Day 21	Day 22	Day 23	Day 24	Day 25
Day 26	Day 27	Day 28	Day 29	Day 30

I'm smiling as I write this challenge and maybe you are, too. It sounds silly, doesn't it? Making a wish each day for 30 days. I invite you to do this for 30 days for several reasons. First being that making a wish reconnects us with our sense of fun, spirit, and childlike behavior. As adults we often forget how important the element of play is. We live lives defined by structure, routine, and often follow strict guidelines and adhere to policies without much thought. While these hold their own importance, they can also take us away from the mindset of simply having fun.

Making a wish each day also allows you to think beyond standard goal setting practices and go deeper into true desires, realms of impossibility, and mindsets that may shift your consciousness in powerful ways. In other words, when you make a wish, you're not restricting yourself. You're giving yourself full permission to take advantage of the universe and its limitless possibilities. You're saying, *"I can wish for ANYTHING"* and you're not holding back.

Wishes can also lead us to discover what we're really craving in our lives. They can get us to move outside of guided focus and intention and instead think in ways that get us in touch with long lost parts of ourselves. You may find that making wishes brings up elements of nostalgia, longing, old memories, or even missed opportunities. Try not to run from any discomfort and instead, dive deeper into what your wish might be trying to tell you on another level. This is where our subconscious mind gets a chance to be heard.

Be bold with your wishes and don't worry about them being plausible or realistic. At the end of 30 days you'll have a list of wishes and you may be surprised how many of them are possible by only shifting a few things in your daily life or routine.

A few wish "templates" to get you started:

- I wish that I had the ability to_____
- I wish that there was limitless_____
- I wish that I had the courage to_____
- I wish that I would take more time to_____
- I wish that more people knew_____

" An obstacle is often a stepping stone. "

-William Prescott

Calendar Tracker

Day 1	Day 2	Day 3	Day 4	Day 5
Day 6	Day 7	Day 8	Day 9	Day 10
Day 11	Day 12	Day 13	Day 14	Day 15
Day 16	Day 17	Day 18	Day 19	Day 20
Day 21	Day 22	Day 23	Day 24	Day 25
Day 26	Day 27	Day 28	Day 29	Day 30

What's a Buddha Book? It started out as a specific journal I keep for myself to house affirmations, quotes, Zen thoughts, intentions, visuals, and anything else that helps me feel grounded and aligned with my true self. I gave it the name Buddha Book because I found that many of the things I was studying during my Master's that resonated with me came from Buddhist teachings and traditions. I use this book as a place to store teachings and inspiration I find that I can reference daily. It's fun to come back to it regularly for reminders on how I want to live and what intentions I truly want to start each day with. It's been a wonderful addition to my meditation practice and find that even looking at it briefly each day lifts my mood and encourages me to live a more intentional life.

Start by choosing a journal or notebook that calls to you. It may be on the smaller size if you wish to take it with you or keep it in your purse or handbag. Make sure it's a journal that you enjoy holding, that has solid pages. Bonus points if you insert a ribbon as a bookmark.

Look for quotes and pictures online or on Pinterest that you can print out to add to your journal. There might be rituals you already do or meditations you wish to follow that you can add as well. Use it to keep lists of things that bring you joy, moments that led to any realizations, or even things others have said that have changed your way of thinking.

Adding to your Buddha Book each day for 30 days will not only give you an amazing and customized feel-good reference tool for your self-care but it also allows you to cultivate resources you may have forgotten about. You may also wish to create pages for things you wish to let go of or new beliefs or ideas you are working on incorporating into your life.

Get more info, watch a video walkthrough of my Buddha Book, and grab your free creation checklist by visiting the my website at **SarahRoseCoaching.com**

" This is my simple religion. There is no need for temples; no need for complicated philosophy. Onn onn brain, our onn heart is our temple; the philosophy of kindness. "

-The Dalai Lama

Calendar Tracker

Day 1	Day 2	Day 3	Day 4	Day 5
Day 6	Day 7	Day 8	Day 9	Day 10
Day 11	Day 12	Day 13	Day 14	Day 15
Day 16	Day 17	Day 18	Day 19	Day 20
Day 21	Day 22	Day 23	Day 24	Day 25
Day 26	Day 27	Day 28	Day 29	Day 30

Challenge 85

*F*eng Shui or "wind water" in English is the Chinese art of harmonizing both the space and everything within it. Feng Shui also ties to the belief of living in harmony with nature. Practices vary and have changed and had more or less significance over time historically. Many ancient tombs and the buildings were arranged in ways to be aligned with the system of Feng Shui.

Over the years with an emergence in the 80s within the United States, Feng Shui has become more popular within Western Culture. Typical of Western society, traditions and beliefs that aren't rooted in scientific studies are often dismissed or discredited, however, many people still practice the art of Feng Shui today and believe in the power of Qi or "life force" energy that surrounds people and the environment around them.

If you've been curious about adding more Feng Shui into your home or want to see how it might affect your life, you can take the next 30 days to shift items and their directions in your home. Please keep in mind that any suggestions I make are merely suggestions and there many amazing sites with specialists who can help you dive much deeper into the art and practice.

The basics of Feng Shui include five power principles. (1) The flow of *Chi* or energy through your home. (2) *The Bagua* which is a chart that determines where certain objects should reside in the home. (3) *The Five Elements* that help define the types of objects which include earth, fire, water, metal, and wood. (4) *Yin and Yang* defined as two opposing but interconnected forces. (5) *Continuity and Connectedness* or how aligned your home feels with the outside world.

To start shifting your home to receive the energies and qualities of these five power principles, you can consider the "flow" of your home as well as how certain rooms or the arrangement of furniture affect your mood and energy levels. I can tell you right now that the mood of my office corner in our 500 square foot tiny home isn't feeling too great at the moment since it's crowded and hard to get into.

The core of Feng Shui is something I think most people can get behind. The way we live in our homes, arrange our possessions, and interact with them affects our quality of life. Cooking quality and nutrition meals in the kitchen can affect your health and having things in place that make that easier will only make you more likely to stay consistent. Having a clean and clear entryway invites good energy into your home especially when you're not tripping over shoes or fumbling around looking for keys. How you feel and what you think will in turn affect how you live your life.

Make time each day to do something that makes your home feel easier to navigate, live in, or walk through. Whether it's a true Feng Shui practice or not, you will be amazed at how much better you feel after 30 days.

Calendar Tracker

Day 1	Day 2	Day 3	Day 4	Day 5
Day 6	Day 7	Day 8	Day 9	Day 10
Day 11	Day 12	Day 13	Day 14	Day 15
Day 16	Day 17	Day 18	Day 19	Day 20
Day 21	Day 22	Day 23	Day 24	Day 25
Day 26	Day 27	Day 28	Day 29	Day 30

Challenge 86

As chaotic as daily life is, it can be hard to remember to check in with ourselves, take a deep breath, come back to center, or do whatever you need to do to feel at ease. By setting a reminder on your phone, on your desktop, or even with sticky notes around the house you'll be able to reconnect with yourself throughout the day and see what's going on. This may sound incredibly simple (and it is) but doing this can drastically change your habits, your mindset, and your reactions to frustrations, especially after 30 days.

When your reminder goes off or you see the note you left on the counter, take 30 seconds to pause, breathe, and exhale. Yep, that's it, I'm only asking you to take 30 seconds. What you may find is that taking time to pause especially when you're prompted to out of the blue will allow you to check in and see if there's anything you need. How many times have you worked through the day and wound up with a headache because you forget to drink water? How many times have you forgotten to eat or not realized that you had a pain in your back that was making you feel cranky? Taking time to check in helps you set mini setpoints throughout your day so you can re-fuel, and make sure your baseline needs are being met.

Most of the time when we start to feel anxious, irritated, upset, or confused, it has to do with something basic not happening for us. But we're complex beings and big thinkers and can tend to jump to bigger conclusions and assumptions without realizing we're just a little *hangry*.

I recommend setting a timer every 2 hours to start, you can then adjust it as you see fit. If you're using a phone alarm or notification title it within something like *breathe, have a glass of water, or stretch*. Over time it may become a habit to take a short break at the top of every hour or you may find that you enjoy the 30 second breathers that you expand on them over time. Do whatever feels best to make this something you can stick to. If you're in the office all day, invite others to participate with you.

" Slow down and everything you are chasing will come around and catch you. "

-John De Paola

Calendar Tracker

Day 1	Day 2	Day 3	Day 4	Day 5
Day 6	Day 7	Day 8	Day 9	Day 10
Day 11	Day 12	Day 13	Day 14	Day 15
Day 16	Day 17	Day 18	Day 19	Day 20
Day 21	Day 22	Day 23	Day 24	Day 25
Day 26	Day 27	Day 28	Day 29	Day 30

*J*ournaling has made a comeback (you're clearly on the trend train as you have this one in your hand). I've been enjoying the endless resources that keep popping up. One of my favorite journal practices involves making lists. Lists of lists I want to make. Lists of books I want to read, lists of places I want to see, lists of cookies I want to bake over the holidays, the list goes on ;)

One great thing about making lists is that it allows you to focus in and clear your mind. You may be thinking, how does making a list of more ideas clear my mind? It helps because instead of focusing on how xyz isn't working in your life right now, you're making a list of names for baby chicks for example (I've so done this by the way). Focusing your attention on something specific reduces stress and allows you to "get in the zone" which is a major component to happiness. Check out the documentary, *Happy*, for more on this. List making is also fun to come back to later when you're in search of ideas for a project, want to know what to do with some extra free time, or forgot what book you have been wanting to read for ages.

Lists can also be a wonderful way to ease stress and anxiety around things you need or don't want to forget. Paula Rizzo, the creator of ListProducer.com uses lists as a productivity strategy to organize her life and save time in the process. During an interview with Forbes, Lisa also shared that people who write down their goals (even in list form) have been shown to be 33% more likely to achieve them than those who don't.

Whether you're looking to make lists for fun, relaxation, or productivity, do what works best for you in terms of where you keep your lists. Writing in a journal can create that strong "mind to paper" connection but if you find you don't come back to it often enough, it might not serve you. Online tools also exist such as EverNote and WorkFlowly that allow you to search notes and lists, add tags, and create categories.

Grab your free printable of 50 Lists to Make When Life Feels Overwhelming by visiting the blog **SarahRoseCoaching.com/blog**

" Thousands of candles can be lighted from a single candle, and the life of the candle will not be shortened. "

-Buddha

Calendar Tracker

Day 1	Day 2	Day 3	Day 4	Day 5
Day 6	Day 7	Day 8	Day 9	Day 10
Day 11	Day 12	Day 13	Day 14	Day 15
Day 16	Day 17	Day 18	Day 19	Day 20
Day 21	Day 22	Day 23	Day 24	Day 25
Day 26	Day 27	Day 28	Day 29	Day 30

Challenge 88

Switch to Natural DIY Household Cleaners

*W*hen I moved into my first apartment at the age of 23 I was over the moon. First because I was also escaping a three year verbally abusive relationship but also because it was my first true place all to myself. About 6 months into living there I decided to adopt a parakeet named Petri. That little dude was a love. He'd follow me around the house, steal my snacks, and sing his little heart out as he gazed out the window at the trees. Once I had him in my apartment, I started researching more about how to be the best bird Mama ever. I found out that candles and the fumes they give off (plus the smoke afterwards) can be very toxic to birds. I was shocked, slightly disappointed, but then also curious how they might be affecting me as well.

Thus began the journey that I'm sure endless other pet and human parents take when they realize they want their home to be as toxic free as possible. I had never once paid any attention to the ingredients or chemicals in household products, detergents, or even my cosmetics and shampoos. I just assumed they were pretty safe. It brought back memories of me running around with Mr. Yuck stickers as a kid and putting them on all the non-edible products around the house.

I was pleasantly surprised to also learn however, that making my own DIY products was rather simple and a lot less expensive. I learned that I could make one type of cleaner with vinegar and use it on virtually everything. I also noticed that I didn't miss the expensive toxic stuff and I no longer felt ridiculously dizzy after trying to clean my bathroom.

Taking 30 days to use up your current household products and start integrating DIY ones is a solid amount of time to make the shift and do it on a budget. If you want to do it all at once, more power to you. Make sure to dispose of any unused cleaners and their containers safely.

Checkout the Environmental Working Group at www.ewg.org for more resources on environmentally conscious and toxic free products and cleaning tips

> *" Happy people continuously change; and because they change they become more and more happy; and then more and more change is possible. "*
>
> *-Osho*

Calendar Tracker

Day 1	Day 2	Day 3	Day 4	Day 5
Day 6	Day 7	Day 8	Day 9	Day 10
Day 11	Day 12	Day 13	Day 14	Day 15
Day 16	Day 17	Day 18	Day 19	Day 20
Day 21	Day 22	Day 23	Day 24	Day 25
Day 26	Day 27	Day 28	Day 29	Day 30

I'm a big believer in two things. (1) That sugar really can affect the brain like crack and (2) That food addictions can also hold as much power over us as we want them to. In other words, I don't discredit the research and findings being done on sugar and the brain but I also know that it varies by person for how much they can have or if they feel like it has to be all or nothing.

I've given up sugar in the past (not including fruits) for months or more and have always found that I end up having more energy, less intense food cravings, and a happier, peppier mood. I've also had times in my life where I felt fine having one cookie, walking away, and not having another sugar craving for weeks. For me personally, a lot of it depends on my mind-body connection and the amount of emotional control I put into my relationship with food.

It can be hard to remove refined sugar from your diet when it's become a regular part of your diet. Every time refined sugar is ingested, especially in the form of a beverage or anything lacking fiber, the body immediately absorbs it and turns it into fat. It also spikes our blood sugar level and then drops dramatically sending our insulin production into overdrive to balance it out. Giving up refined sugar for 30 days can help you become more in tune with your body, your cravings, and your true sense of hunger.

A good way to start is to simply remove any added sugar you put on any foods. When I was younger my brother and I used to pour white sugar on our cereal by the spoonful and then eat the clumps at the bottom, it still grosses me out thinking about it. Next steps can be reducing the amount of processed foods you consume and instead moving to whole plant based foods that contain their full nutrient value.

You may find it helpful to keep a food log or a diary about your sugar intake, taking note of your mood, energy levels, and so forth. It's normal to feel sugar withdrawals when you start. Be patient with yourself and don't feel like you have to be perfect. This is about building the awareness with your body.

For more guidance on intuitive eating, checkout my lovely friend and Intuitive Eating Health Coach, Lauren Stewart at livemorewithlauren.com

" When you are content to be simply yourself and don't compare or compete, everybody will respect you. "

-Lao Tzu

Calendar Tracker

Day 1	Day 2	Day 3	Day 4	Day 5
Day 6	Day 7	Day 8	Day 9	Day 10
Day 11	Day 12	Day 13	Day 14	Day 15
Day 16	Day 17	Day 18	Day 19	Day 20
Day 21	Day 22	Day 23	Day 24	Day 25
Day 26	Day 27	Day 28	Day 29	Day 30

Challenge 90

When I worked a 9-5 I had a strict rule about ending any caffeine intake after 12PM. That rule started slipping after I moved cross country with my husband and found myself working contract jobs, going back to school, and starting my own business. My hours shifted, I had later nights, and big projects to finish on short deadlines. Grad School, am I right?! The problem is that drinking caffeine all day can really start to mess with our sleep cycles as well as how much iron we can absorb which also contributes to energy levels.

Noon is an arbitrary time I chose because it's what I've used in the past with my personal schedule. For this challenge, choose a time in the day that makes the most sense for you. If your day doesn't start until 11 a.m., who am I to tell you to stop having coffee after 12 p.m.? If you've been up for 5-6 hours, it's probably a good time to decrease the caffeine intake. I also notice that if I have caffeine later in the day it makes me shaky, incredibly warm, and physically uncomfortable. I'll never forget how impossibly tired I felt driving cross country yet how unable I was to sleep after chugging coffee non stop day after day. It wasn't my best week.

Ending your caffeine intake can also help you replace it with a healthier alternative like another water bottle, a short walk around the block, or a brief breathing exercise. During these 30 days notice how it feels to remove caffeine from your afternoons. Be aware of sneaky sources of caffeine as well. Ditch the sodas and opt for decaf teas. Add lemon to your water and find other ways to boost your energy like a few stretches or some yoga eye movements to take the strain off your screen time.

Overtime you may find that your afternoon slump dissipates or ends completely. If you do find yourself in need of a energy boost in the afternoon, find a way to laugh or take your mind off whatever you might be working on briefly. Cat videos and memes became popular for a reason.

" Life is not what it's supposed to be. It's what it is. The way you cope with it is what makes the difference. "

-*Virginia Satir*

Calendar Tracker

Day 1	Day 2	Day 3	Day 4	Day 5
Day 6	Day 7	Day 8	Day 9	Day 10
Day 11	Day 12	Day 13	Day 14	Day 15
Day 16	Day 17	Day 18	Day 19	Day 20
Day 21	Day 22	Day 23	Day 24	Day 25
Day 26	Day 27	Day 28	Day 29	Day 30

During one of my past jobs my supervisor put together a green potluck every Saint Patrick's day. I loved it because everyone seemed to bring in guacamole—quite possible the best food on the planet and it was filled with healthy and delicious foods. One thing I love about this challenge is that it gives you a visual cue that you're on track. Adding something green to your meal may sound a bit daunting at first but I'm here to walk you through it and show you some easy ways to make it happen. Whether it's a huge portion of your meal that ends up being green or a sprinkle of cilantro to make it work, it's all good. The main point here is to incorporate more plant foods into your diet, the kinds of foods that truly fuel healing, well being, and optimum energy.

Salads and avocados may have come to mind already but how will you get greens in the morning for breakfast? One of the easiest ways is to have a green smoothie in the morning (checkout challenge #60). You could also have an apple on the side or over oatmeal, avocado toast, zucchini muffins or pancakes, or even sauteed spinach (don't knock it til you try it).

Lunches could include any breakfast items as well as salads with spinach, chard, arugula, lettuce, zucchini pasta (veggie spiralizers are amazing), peppers, chives, homemade veggie sushi, sandwiches with extra greens, and more!

Season dinners with sage, cilantro rice, oregano, and other spices. Have a crock pot bean chili with celery. Add steamed broccoli, artichoke hearts, grilled asparagus, or other vegetables to your meal. Make a Buddha Bowl with rice, veggies, beans, carrots, and dressing.

Have fun seeing how green you can make your meals with plants. Take photos of your meals for 30 days. I have an entire album of healthy food I've made that I reference when I need meal ideas. Check out hashtags on Instagram. Challenge friends and family to join you. Try new vegetables and plants in the produce section you've never heard of before. Get adventurous, improve your health!

" Enlightenment is understanding that there is nonhere to go, nothing to do, except exactly who you're being right now."

-Neale Donald Walsch

Calendar Tracker

Day 1	Day 2	Day 3	Day 4	Day 5
Day 6	Day 7	Day 8	Day 9	Day 10
Day 11	Day 12	Day 13	Day 14	Day 15
Day 16	Day 17	Day 18	Day 19	Day 20
Day 21	Day 22	Day 23	Day 24	Day 25
Day 26	Day 27	Day 28	Day 29	Day 30

Keeping track of what you're eating can be a great way to build your awareness around food and see what kind of nutrients you're getting. I also want to caution that it can be a trigger for perfectionists and people with eating disorders. There was a time in high school where I was counting TicTac calories and thinking diet sodas counted as a meal. Please do not count calories if you know it's a tricky mental place for you to be. There's nothing wrong with anyone who feels this way, it's unique to everyone and it's important you do what's best for you.

When I went vegan back in 2015, I was super curious to see how my new way of eating would impact my nutrients. I had a lot of fun using LoseIt to track things like fiber intake, protein, sugar, fat, etc. I was most surprised by the volume of food I was able to eat and how little calories I was eating. I'd also never been able to effortlessly eat 40g of fiber or more in a day.

Food trackers like LoseIt, MyFitnessPal, and Chronometer, can be helpful if you're looking to track calories, meet specific fitness goals, or want to know more about your food intake patterns and both the micro and macro nutrients you're consuming. One thing I love is that I was able to see patterns in how certain meals at breakfast would trend toward me eating more or less throughout the day.

Food trackers aren't the only way to track your food however. You may find that tracking every meal and calorie is tedious and unnecessary. In that case you may find that having a food journal where you can reflect on your mood, energy level, and cravings is more helpful in allowing you to eat more intuitively over time.

Log your meals for 30 days and notice what changes. Many times when we bring awareness to something we automatically make changes because of what we notice. For example, I tend to come back to tracking my food every few months to see what might be changing or if I feel like I've been mindlessly eating a bit more than usual. It's nice to have a way to get back on track and see ways in which eating patterns, seasons, and types of foods can impact daily life.

" Life is really simple,
but we insist on making it complicated. "

-Confucius

Calendar Tracker

Day 1	Day 2	Day 3	Day 4	Day 5
Day 6	Day 7	Day 8	Day 9	Day 10
Day 11	Day 12	Day 13	Day 14	Day 15
Day 16	Day 17	Day 18	Day 19	Day 20
Day 21	Day 22	Day 23	Day 24	Day 25
Day 26	Day 27	Day 28	Day 29	Day 30

Challenge 93

Back in challenge #87 I had you write a list each day. For this challenge, I want you to add daily to specific lists surrounding books you want to read or movies you want to see. I bring up these two lists because they are the top things that people tend to forget, myself included, and I believe that they are a huge element of our self-care over time. Having a list of books you want to read or movies you want to see is a great way to know what you're interested in (and if that changes over time) as well as a reference place for when you get time to relax, read, or check out the local theater.

This challenge is pretty darn simple but just imagine how many ideas you'll have for books and movies by the end of the month. Don't pressure yourself to come up with endless lists each day, instead write down at least 1-2 books or movies each day. They can be old or new or something you've already read or watched before. As the days go on, reach out to friends, coworkers, and online buddies to see what their favorites are. Let people know the kinds of genres you like so you aren't inundated with stuff you have little interest in.

As you make your list you can also start to curate or see where some of these are available. Your local library may have most of the books you want to read, or friends may have books they are willing to let you borrow. As you make your list, create a space next to each one where you can write down where to find the book or watch the movie. It can be fun to write down release dates for upcoming films or networks that may broadcast older movies. Have fun creating your own little library of things you want to absorb, learn from, and enjoy. By the end of the month you'll have a full personalized reading and movie list to get you started on the next stormy night or day at the beach.

" Nobody can go back and start a new beginning, but anyone can start today and make a new ending. "

-Maria Robinson

Calendar Tracker

Day 1	Day 2	Day 3	Day 4	Day 5
Day 6	Day 7	Day 8	Day 9	Day 10
Day 11	Day 12	Day 13	Day 14	Day 15
Day 16	Day 17	Day 18	Day 19	Day 20
Day 21	Day 22	Day 23	Day 24	Day 25
Day 26	Day 27	Day 28	Day 29	Day 30

Challenge 94

Dedicate a Journal
for All Your Ideas
and Add to it Daily

I have a lot of journals. My husband might say it's a problem. I say it's a passion. I have journals for lists, journals for rants, journals for self-care (like this one), and journals for weekly tasks and to-dos. I love having something I can hold in my hands and reference. It's also insanely fun to decorate pages with washi tape, Lisa Frank stickers, and colorful markers.

Keeping an idea journal can be a wonderful way to capture any and all of your ideas big or small. Whether you end up turning them into a reality or crossing them off as something you never plan on doing, it's fun to see your mind expand and everything that you come up with. I wish I had kept more journals not only as a kid but throughout my adult life thus far. Even looking back at ideas I had a couple years ago is fascinating to me.

Having one specific place for all of your random ideas, thoughts, mind maps, and brain storm sessions can also create structure to your life and help you avoid the hell that is endless loose papers, sticky notes that have lost their stick, and notepads that are cluttering up your desk.

If you're not sure where to get started with a journal like this it can be helpful to create a list of page ideas in the index (the first few pages) of your journal that you can reference and fill out as you go. Creating mind map templates ahead of time, writing out processes you do all the time, and keeping track of how you do things currently can be extremely helpful for referencing later. Some ideas you might want to keep track of could be ways to make things more efficient at work or at home, craft projects, writing ideas, gift ideas for family and friends, ideas for parties, events, or annual trips, etc. Labeling your pages and categorizing your ideas into different sections can also be a helpful way to be able to reference them later or know where to place new ideas.

" *The difference between those who succeed and those who fail isn't what they have—it's what they choose to see and do with their resources and their expertise of life.* "

-Anthony Robbins

Calendar Tracker

Day 1	Day 2	Day 3	Day 4	Day 5
Day 6	Day 7	Day 8	Day 9	Day 10
Day 11	Day 12	Day 13	Day 14	Day 15
Day 16	Day 17	Day 18	Day 19	Day 20
Day 21	Day 22	Day 23	Day 24	Day 25
Day 26	Day 27	Day 28	Day 29	Day 30

Challenge 95

When I look back at what I did when I had extremely efficient and successful periods in my life, one of the things I was doing consistently was packing my lunch ahead of time. Crazy successful people aren't inherently more amazing or capable than the everyday person, they are just consistent with things they do each day and have mini systems for keeping their lives functioning. Packing your lunch allows you to make healthier decisions ahead of time, saves you stress in the morning, helps you reduce decision fatigue and overwhelm, and allows you to walk out the door feeling that extra bit accomplished. Packing my lunch also made it a lot easier to avoid donuts in the break room and saved me a lot of money from last minute convenience foods or lunches out at restaurants. Knowing I had a lunch packed with health snacks for the day really made my life easier.

It also helped me near the end of the work day when I needed or wanted an afternoon snack. My go to snacks are usually an ounce of nuts, a banana, an apple with peanut butter, or some sliced bell peppers with hummus. Now that I'm at home most days, I am realizing that prepping my snacks and meals ahead of time still holds a lot of value. I cannot tell you how much time I waste by wandering into the kitchen when I'm hungry, opening cupboards, scratching my head, and wondering what I want or what we have. All this to say that meal prepping even if you aren't leaving the house can be extremely helpful. I mentioned decision fatigue before and this is one of the leading reasons it can be hard to make healthy choices. Making decisions for yourself ahead of time frees up a lot of mental energy and allows you to continue on in your day without having to stress over what you "should" eat for lunch.

Here's a short list of easy lunch ideas to get you started:

- Build a salad in a mason jar with all of the "dry" ingredients like onions and carrots, then add salsa, hummus, dressing, avocado, oranges, beans, or whatever else you want on top.
- Buy a mini rice cooker you can keep at your desk or in the breakroom. Hint: rice cookers can make a lot more than just rice. Take everything you need to work in a bowl and then cook before lunch. Checkout High Carb Hannah on YouTube for healthy and delicious meal suggestions.
- Make sandwiches ahead of time such as PBJ, chickpea tuna, tomato avocado and hummus, or any of your favorites.

" Courage is not the absence of fear, but rather the judgment that something else is more important than fear. "

-Ambrose Redmoon

Calendar Tracker

Day 1	Day 2	Day 3	Day 4	Day 5
Day 6	Day 7	Day 8	Day 9	Day 10
Day 11	Day 12	Day 13	Day 14	Day 15
Day 16	Day 17	Day 18	Day 19	Day 20
Day 21	Day 22	Day 23	Day 24	Day 25
Day 26	Day 27	Day 28	Day 29	Day 30

This challenge is super simple and builds on some of the other ones we've talked about. You may have noticed how I've broken down many of these challenges into even more specific actions. That's because I find that it's easier to shift habits and create time for more self-care when we start small. If there's something you have every morning without fail whether it's black coffee, water with lemon, or oatmeal, take a few minutes to consider how you could make it even easier for yourself. I'm a big fan of black coffee and yes, it's definitely an addiction (hello caffeine withdrawal headaches) but it's also one of my only vices. Maybe someday I'll give it up completely, but for now, I love my morning Cup of Joe.

Taking time in the evening to wipe down the countertops, clear the sink, set the coffee, or prep some overnight oats is pure self-love. It's taking care of your future self with a simple action in the present moment. It's saying *"hey, I know mornings aren't always your favorite, so I'm doing this for you so you don't have to worry about it."* Look how nice you are! It also ensures that you get that time to have something you love in the morning. Nothing feels more frustrating than waking up to a kitchen disaster without the coffee going only to have to do three extra things before I can even get my day started. Why make it more challenging to get up in the morning?

If you can't tell, I've been drilling the idea of a nightly routine into your mind frequently throughout this book. I say it over and over again because it truly can be life changing. So set a time to set that coffee, make those oats, or do whatever you need to do to make the mornings run smoothly. Soon it will be a part of your habitual and healthy routine in the evenings and you'll only thank yourself for it again and again.

"If you want to be happy, set a goal that commands your thoughts, liberates your energy, and inspires your hopes."

-Andrew Carnegie

)))●● Calendar Tracker ●●((

Day 1	Day 2	Day 3	Day 4	Day 5
Day 6	Day 7	Day 8	Day 9	Day 10
Day 11	Day 12	Day 13	Day 14	Day 15
Day 16	Day 17	Day 18	Day 19	Day 20
Day 21	Day 22	Day 23	Day 24	Day 25
Day 26	Day 27	Day 28	Day 29	Day 30

We've talked about putting away devices two hours before you go to sleep but this challenge helps you focus on something a little different. I can get so addicted to the internet, various newsfeeds, checking Instagram, and every other social media app under the sun. Sometimes it almost feels impulsive like I can't put my phone down until all the notifications are gone. That's when I know it's time to tone down the interweb time.

What's the first thing you do when you get home? For a lot of people it involves the couch, their phone, the TV, maybe some snacks, and then what-the-crap-I-suddenly-have-to-go-to-bed. The internet is a time suck. Yes there's value there but honestly, how often do you leave the internet feeling recharged, refreshed, and rejuvenated? Exactly. Chances are you aren't striding into work Monday morning talking about your amazing weekend in front of your laptop. *"I read so many Buzzfeed articles, found out my cat's horoscope, and didn't even go outside!"*

Okay, granted, those weekends definitely can feel amazing but my point is that when we step away from the endless internet feed, we tend to feel better. We give ourselves the opportunity to look inward and stop using entertainment as distractions for things we might not be willing to face. Staying off the internet in the evening also challenges you to do (dun dun dun) other things. Things like reading, crafting, having real conversations with people you may live with, eating dinner as a family, taking a walk outside, cooking instead of ordering out, or even going out and doing something after a long day.

Scrolling through newsfeeds is also extremely mentally draining. When you think about it you're allowing anything and everything into your mind without much of a filter. Subconsciously you're reacting to everything you see, feeling an emotional response that can trigger physical reactions, all while not building any awareness around what's happening. It's one of the reasons you may leave Facebook or any other platform feeling drained, oddly sad, or unmotivated.

See what you end up doing with your evenings without the internet for 30 days!

"Remember that life develops what it demands— the toughest path creates the strongest warrior. Pray not for a lighter load, but for stronger shoulders."

-Dan Millman

Calendar Tracker

Day 1	Day 2	Day 3	Day 4	Day 5
Day 6	Day 7	Day 8	Day 9	Day 10
Day 11	Day 12	Day 13	Day 14	Day 15
Day 16	Day 17	Day 18	Day 19	Day 20
Day 21	Day 22	Day 23	Day 24	Day 25
Day 26	Day 27	Day 28	Day 29	Day 30

*H*ave you ever made a visualization board? I used to make them often as a kid but have found they can be a great tool as an adult as well. There are many ways to go about it depending on how crafty or artistically inclined you are. Create a Pinterest moodboard for how you want something to look or feel or make a full on cut out board with pictures printed out and glued to it. Mind maps are also a great way to add to your board.

So why create a visualization board? I'm not here to tell you that creating something like this and then walking away will help it manifest in your life but what it can do is help you get super clear on what you want and how to get it. That last part is key. Visualization boards can help you "see" and visualize the dream lifestyle or next goal you want to reach.

I've broken it down into few key steps for making a visualization board that can actually help change an area of your life.

Get clear on your intentions

Choosing pictures off the internet or magazines that are visually appealing and pasting them onto a stock paper board is fun but it's doubtful it will help bring clarity to your life. Before starting, ask yourself the following questions:

- *What are your current core values?*
- *How do you really want to feel? What does that look like? What needs to change?*
- *What are you seeking or craving more of in your life right now?*

After you've taken some time to answer these questions, you'll then be able to narrow your board down to a specific want, need, or desire. This will be a lot more effective than a collage of random things you like.

Hold and create a space to work on your visualization board

Find ways to make the experience more enjoyable. Make some tea, get cozy, find a space that you can spread out and gather any supplies you'll need, even better if you can keep your project "in the works" for the full 30 days in the same space. In other words, create a place if possible where you won't feel like you're in the way.

Come back to it daily

This challenge is all about both looking and adding to your board daily. That can mean adding new images or words but it can also mean adding to a list of ways to make this vision a reality. Ask yourself, how can you start living this goal now?

 Visualization board ideas:
- *Moodboards: cozy vibes, home ideas, relationships, etc.*
- *Bucket list items such as places you want to visit or experiences you want to have*
- *Money and income*
- *New items such as a home, a car or furniture*
- *Fitness goals and inspiration: think accomplishments over looks alone like running a 5K*

Calendar Tracker

Day 1	Day 2	Day 3	Day 4	Day 5
Day 6	Day 7	Day 8	Day 9	Day 10
Day 11	Day 12	Day 13	Day 14	Day 15
Day 16	Day 17	Day 18	Day 19	Day 20
Day 21	Day 22	Day 23	Day 24	Day 25
Day 26	Day 27	Day 28	Day 29	Day 30

Challenge 99

What's the first thing you get asked at parties and networking events? My guess is that it's something along the lines of, what do you do? I hate this question for a plethora of reasons I'll spare you from but it does bring up the questions of why are we so interested in what people "do" instead of how people feel or what they're excited about.

I recently read a thread in a forum where people were talking about alternatives to the "What do you do?" question and the one that stuck out the most was "What are you most excited about right now?" Ooooo! Even hearing that question makes me excited to hear their answer. When we ask people what they do, we're taking away the opportunity to explore who they are, what lights them up, and what they are passionate about. Sure, some people are working and doing what they love but the question is often so surface level that it doesn't go anywhere. Maybe it's just me but I hate small talk, I'd much rather leave an interaction hearing something profound, unique, and thought provoking than hear another exhausted person try to explain what they do for 8 hours a day at a desk.

For the next 30 days of this challenge, your task is to ask a new person each day what makes them happier than anything else. You could of course reframe it to something else to fit the situation. Feel free to use the other question as well. Here's the important part. Keep track of what people say. Use the boxes of the 30 day challenge tracker to write them in or expand on them in a separate journal. Hearing what other people are passionate about is fascinating. You may even wish to ask more than one person per day. Heck, tell them you're doing a happiness project and go nuts. My tip to you is to ask people in person, face to face, when possible. We're a little less filtered this way. Emails, calls, and text messages can be wonderful ways of communicating but most of the time, people filter themselves through their writing.

"Happiness consists not in having much,
but in being content with little."

-Marguerite Gardiner

Calendar Tracker

Day 1	Day 2	Day 3	Day 4	Day 5
Day 6	Day 7	Day 8	Day 9	Day 10
Day 11	Day 12	Day 13	Day 14	Day 15
Day 16	Day 17	Day 18	Day 19	Day 20
Day 21	Day 22	Day 23	Day 24	Day 25
Day 26	Day 27	Day 28	Day 29	Day 30

Challenge 100

Do Something Spontaneous or Out of the Ordinary

I won't be able to give you that much guidance for this particular challenge because it's completely up to you. Start by asking yourself what it even means for you to be spontaneous. It's different for everyone. Some of us lead very structured lives while others barely have a daily schedule. Spontaneity may mean deciding to have more structure one day or less the other. Another way you can start is by taking an inventory of what structure you do have in your life. Think beyond wake up times and meetings and consider everyday and regular choices that you barely consider anymore. These could be things like what kinds of products you purchase, where you go out to dinner, what gas station you always stop at, the road you take on the way home, or even how you say good morning to people at work.

I'm all for routine but there's something a little magical that happens when we shift things slightly. Say for example that you always go for a run in a particular park on Saturdays, what if that walk turned into a hike at an entirely new location, or a swim at the pool, or a hot yoga class at a local studio you've never even considered going to. Think about how different the experience would be, what you might realize, enjoy, or learn about yourself.

Spicing things up with spontaneity and change can also boost our happiness. One of my favorite things to do is to take my time grocery shopping and find new foods to try. There are so many fruits, greens, and vegetables in the produce section that I've yet to try. I always get a rush when I bring something new home and have to figure out (1) what it even is and (2) how to prepare it. I once made an entire dish with what I thought were leeks only to discover that they were bok choi. It's still something I laugh about.

As you go through this 30 day challenge, make a list of new ideas you have, new things you could try, ways you could shift up your daily routine, new words you might want to incorporate into your vocabulary (see challenge #51), or new self-care activities you might want to try in this book! If you ever find yourself running out of ideas, ask friends for suggestions. It's amazing to learn what people in our lives do on a daily basis that can be drastically different. You can also checkout mymorningroutine.com for more suggestions and a fun look at various morning routines.

*"Remember there's no such thing as a small act of kindness.
Every act creates a ripple with no logical end."*

-Scott Adams

Calendar Tracker

Day 1	Day 2	Day 3	Day 4	Day 5
Day 6	Day 7	Day 8	Day 9	Day 10
Day 11	Day 12	Day 13	Day 14	Day 15
Day 16	Day 17	Day 18	Day 19	Day 20
Day 21	Day 22	Day 23	Day 24	Day 25
Day 26	Day 27	Day 28	Day 29	Day 30

Bonus

Create your own 30 day challenges!

Use the following templates to create your own 30 day challenge. Use a different challenge from this book for each day or create a new challenge idea!

Challenge Overview: _____

Option #1: Choose a different challenge for each day/week and mark it in the calendar on the opposite page to keep track of your progress.

Option #2: Write about the challenge in detail and explain the benefits of committing to it for 30 days. If there is a personal story as to why you chose a particular challenge, please do tell! This will be another facet of self-care that is customized by you, for YOU!

Tips or Inspirational Quote: _Add your own tips or your favorite inspirational quote to help you throughout the 30 day process!_

Calendar Tracker

Day 1	Day 2	Day 3	Day 4	Day 5
Fill in days according to the option you chose on the previous page.				
Day 6	Day 7	Day 8	Day 9	Day 10
Day 11	Day 12	Day 13	Day 14	Day 15
Day 16	Day 17	Day 18	Day 19	Day 20
Day 21	Day 22	Day 23	Day 24	Day 25
Day 26	Day 27	Day 28	Day 29	Day 30

Challenge 101

Challenge Overview: _____

Tips or Inspirational Quote: _____

Calendar Tracker

Day 1	Day 2	Day 3	Day 4	Day 5
Day 6	Day 7	Day 8	Day 9	Day 10
Day 11	Day 12	Day 13	Day 14	Day 15
Day 16	Day 17	Day 18	Day 19	Day 20
Day 21	Day 22	Day 23	Day 24	Day 25
Day 26	Day 27	Day 28	Day 29	Day 30

Challenge 102

Challenge Overview: _____

Tips or Inspirational Quote: _____

Calendar Tracker

Day 1	Day 2	Day 3	Day 4	Day 5
Day 6	Day 7	Day 8	Day 9	Day 10
Day 11	Day 12	Day 13	Day 14	Day 15
Day 16	Day 17	Day 18	Day 19	Day 20
Day 21	Day 22	Day 23	Day 24	Day 25
Day 26	Day 27	Day 28	Day 29	Day 30

Challenge 103

Challenge Overview: _____

Tips or Inspirational Quote: _____

Calendar Tracker

Day 1	Day 2	Day 3	Day 4	Day 5
Day 6	Day 7	Day 8	Day 9	Day 10
Day 11	Day 12	Day 13	Day 14	Day 15
Day 16	Day 17	Day 18	Day 19	Day 20
Day 21	Day 22	Day 23	Day 24	Day 25
Day 26	Day 27	Day 28	Day 29	Day 30

Challenge 104

Challenge Overview: _____

Tips or Inspirational Quote: _____

Calendar Tracker

Day 1	Day 2	Day 3	Day 4	Day 5
Day 6	Day 7	Day 8	Day 9	Day 10
Day 11	Day 12	Day 13	Day 14	Day 15
Day 16	Day 17	Day 18	Day 19	Day 20
Day 21	Day 22	Day 23	Day 24	Day 25
Day 26	Day 27	Day 28	Day 29	Day 30

Challenge 105

Challenge Overview:

Tips or Inspirational Quote: _____

Calendar Tracker

Day 1	Day 2	Day 3	Day 4	Day 5
Day 6	Day 7	Day 8	Day 9	Day 10
Day 11	Day 12	Day 13	Day 14	Day 15
Day 16	Day 17	Day 18	Day 19	Day 20
Day 21	Day 22	Day 23	Day 24	Day 25
Day 26	Day 27	Day 28	Day 29	Day 30

Challenge 106

Challenge Overview:

Tips or Inspirational Quote: _____

Calendar Tracker

Day 1	Day 2	Day 3	Day 4	Day 5
Day 6	Day 7	Day 8	Day 9	Day 10
Day 11	Day 12	Day 13	Day 14	Day 15
Day 16	Day 17	Day 18	Day 19	Day 20
Day 21	Day 22	Day 23	Day 24	Day 25
Day 26	Day 27	Day 28	Day 29	Day 30

Challenge 107

Challenge Overview: _____

Tips or Inspirational Quote: _____

Calendar Tracker

Day 1	Day 2	Day 3	Day 4	Day 5
Day 6	Day 7	Day 8	Day 9	Day 10
Day 11	Day 12	Day 13	Day 14	Day 15
Day 16	Day 17	Day 18	Day 19	Day 20
Day 21	Day 22	Day 23	Day 24	Day 25
Day 26	Day 27	Day 28	Day 29	Day 30

Challenge 108

Challenge Overview: _____

Tips or Inspirational Quote: _____

Calendar Tracker

Day 1	Day 2	Day 3	Day 4	Day 5
Day 6	Day 7	Day 8	Day 9	Day 10
Day 11	Day 12	Day 13	Day 14	Day 15
Day 16	Day 17	Day 18	Day 19	Day 20
Day 21	Day 22	Day 23	Day 24	Day 25
Day 26	Day 27	Day 28	Day 29	Day 30

Challenge 109

Challenge Overview: _____

Tips or Inspirational Quote: _____

Calendar Tracker

Day 1	Day 2	Day 3	Day 4	Day 5
Day 6	Day 7	Day 8	Day 9	Day 10
Day 11	Day 12	Day 13	Day 14	Day 15
Day 16	Day 17	Day 18	Day 19	Day 20
Day 21	Day 22	Day 23	Day 24	Day 25
Day 26	Day 27	Day 28	Day 29	Day 30

Challenge 110

Challenge Overview: _____

Tips or Inspirational Quote: _____

Calendar Tracker

Day 1	Day 2	Day 3	Day 4	Day 5
Day 6	Day 7	Day 8	Day 9	Day 10
Day 11	Day 12	Day 13	Day 14	Day 15
Day 16	Day 17	Day 18	Day 19	Day 20
Day 21	Day 22	Day 23	Day 24	Day 25
Day 26	Day 27	Day 28	Day 29	Day 30

Challenge 111

Challenge Overview: _____

Tips or Inspirational Quote: _____

Calendar Tracker

Day 1	Day 2	Day 3	Day 4	Day 5
Day 6	Day 7	Day 8	Day 9	Day 10
Day 11	Day 12	Day 13	Day 14	Day 15
Day 16	Day 17	Day 18	Day 19	Day 20
Day 21	Day 22	Day 23	Day 24	Day 25
Day 26	Day 27	Day 28	Day 29	Day 30

Challenge 112

Challenge Overview:

Tips or Inspirational Quote:

Calendar Tracker

Day 1	Day 2	Day 3	Day 4	Day 5
Day 6	Day 7	Day 8	Day 9	Day 10
Day 11	Day 12	Day 13	Day 14	Day 15
Day 16	Day 17	Day 18	Day 19	Day 20
Day 21	Day 22	Day 23	Day 24	Day 25
Day 26	Day 27	Day 28	Day 29	Day 30

Challenge 113

Challenge Overview: _____

Tips or Inspirational Quote: _____

Calendar Tracker

Day 1	Day 2	Day 3	Day 4	Day 5
Day 6	Day 7	Day 8	Day 9	Day 10
Day 11	Day 12	Day 13	Day 14	Day 15
Day 16	Day 17	Day 18	Day 19	Day 20
Day 21	Day 22	Day 23	Day 24	Day 25
Day 26	Day 27	Day 28	Day 29	Day 30

Challenge 114

Challenge Overview: _____

Tips or Inspirational Quote: _____

Calendar Tracker

Day 1	Day 2	Day 3	Day 4	Day 5
Day 6	Day 7	Day 8	Day 9	Day 10
Day 11	Day 12	Day 13	Day 14	Day 15
Day 16	Day 17	Day 18	Day 19	Day 20
Day 21	Day 22	Day 23	Day 24	Day 25
Day 26	Day 27	Day 28	Day 29	Day 30

Challenge 115

Challenge Overview:

Tips or Inspirational Quote:

Calendar Tracker

Day 1	Day 2	Day 3	Day 4	Day 5
Day 6	Day 7	Day 8	Day 9	Day 10
Day 11	Day 12	Day 13	Day 14	Day 15
Day 16	Day 17	Day 18	Day 19	Day 20
Day 21	Day 22	Day 23	Day 24	Day 25
Day 26	Day 27	Day 28	Day 29	Day 30

Closing Notes

I hope that this journal brings you closer to your true self, the core of who you are, and serve as a reminder to do things each day you love. That in itself, is the ultimate form of self-car I've learned that within every experience we have, big or small, there's a lesson to be learne and something to be discovered. Life will continue to pull us in endless directions but w always have the ability to come back to our breath, our heart space, and the present mome and decide where we want to go from there.

Keep living your dreams. Keep doing you. This life is yours to enjoy.

✓	Life Challenges	Page #	Date Completed
☐	59. Drink green tea	124	_____ / _____ / _____
☐	60. Start your morning with a green smoothie	126	_____ / _____ / _____
☐	61. Go a month without makeup	128	_____ / _____ / _____
☐	62. Walk 10,000 steps	130	_____ / _____ / _____
☐	63. Take 10 deep breaths in the morning and before bed	132	_____ / _____ / _____
☐	64. Bake something	134	_____ / _____ / _____
☐	65. Write down something you did each day that made you feel proud	136	_____ / _____ / _____
☐	66. Keep a list of what you accomplished each day	138	_____ / _____ / _____
☐	67. Start using a Bullet Journal	140	_____ / _____ / _____
☐	68. Keep track of your expenses	142	_____ / _____ / _____
☐	69. Listen to a guided relaxation or meditation	144	_____ / _____ / _____
☐	70. Drive somewhere new	146	_____ / _____ / _____
☐	71. Visit a new coffee shop/store/area of your town	148	_____ / _____ / _____
☐	72. Go to a park	150	_____ / _____ / _____
☐	73. Visit the library	152	_____ / _____ / _____
☐	74. Go 30 days without watching TV	154	_____ / _____ / _____
☐	75. Drink seltzer water instead of soda	156	_____ / _____ / _____
☐	76. Make time each day to do absolutely nothing	158	_____ / _____ / _____
☐	77. Turn off all electronics two hours before bed	160	_____ / _____ / _____
☐	78. Write down negative thoughts	162	_____ / _____ / _____
☐	79. Set a bedtime and stick to it	164	_____ / _____ / _____
☐	80. Look in the mirror and say out loud what you love about your body	166	_____ / _____ / _____
☐	81. Try daily dry brushing	168	_____ / _____ / _____
☐	82. Pull a daily Tarot or Oracle card for fun	170	_____ / _____ / _____
☐	83. Make a wish	172	_____ / _____ / _____
☐	84. Add a page to your Buddha Book	174	_____ / _____ / _____
☐	85. Add more Feng Shui to your home	176	_____ / _____ / _____
☐	86. Set a reminder every few hours to check in on yourself	178	_____ / _____ / _____
☐	87. Write a list each day	180	_____ / _____ / _____